ON-THE-LEVEL

ON-THE-LEVEL

By Patricia McLagan
and Peter Krembs

ON-THE-LEVEL

McLagan International, Inc., 1700 West Highway 36, Suite 300, St. Paul, MN 55113

Copyright © 1982, 1988 by McLagan International, Inc.

ISBN 0913147-03-6

Printed in the United States of America

FOREWORD

The basic premise of this book is that On-The-Level communication — direct, deliberate, output focused, shared responsibility communication — is an essential ingredient of doing business in today's Information Age. Contemporary business operations require informed participation throughout an organization. In contrast, businesses operating in the Industrial Age confined decision making to the executive ranks. In our view, this practice is no longer a competitive advantage. Responsible and informed participation — made possible through On-The-Level communication at all levels of an organization — is necessary for business success in today's rapidly changing work environment.

This book focuses on using On-The-Level communication in discussions about performance and development in your organization. However, it has application in the workplace beyond discussion of performance and development issues. Whenever the output of work must be greater than the contribution of a single individual — when teamwork, innovation, trust, and quick response are required — individuals must be able to communicate On-The-Level.

Patricia McLagan
Peter Krembs

CONTENTS

ON-THE-LEVEL

ON-THE-LEVEL

HOW TO USE THIS BOOK

ON-THE-LEVEL is for managers and employees, and managers as employees. It is designed to help you plan and execute more effective and less fearful face-to-face communication.

Each chapter in ON-THE-LEVEL is devoted to applying principles of On-The-Level communication in one of these five performance and development areas:

Chapter One: Goal Setting

Chapter Two: Performance Observation

Chapter Three: Giving and Getting Feedback

Chapter Four: Delivering and Digesting Tough Messages

Chapter Five: Development Planning

Use This Book to Help You Change the Way You Communicate

ON-THE-LEVEL is designed for interactive learning. There's plenty of opportunity for you to pause and think about how the issues and actions discussed relate to you and how you can use these ideas to improve your situation. This is done by dividing each chapter into three broad sections. Generally speaking, the first section of each chapter helps you get motivated, the second helps you learn, and the third shows you how to take action.

Get motivated. The first section of each chapter begins with an *anecdote* that illustrates the practical importance of using On-The-Level communication in the performance and development area discussed in the chapter. The anecdote is followed by a list of common pitfalls — blocks to communicating effectively in the area presented. They are designed to get you into the material emotionally, to let you see yourself in situations that call for using On-The-Level communication skills, and to make you want to learn how you can do so.

Learn. The second section of each chapter presents *action ideas* — specific ways that you can apply On-The-Level principles in your interactions at work. Each action idea is followed by an action

summary that briefly restates the key points and gives suggestions on how to use the ideas in your situation.

Take action. The third section of each chapter begins with "Where Do You Stand?", an informal *list of questions* that gives you a chance to assess how and if you are using the action ideas presented in the chapter, and to plan how you'll take action to implement them or implement them more successfully. The questions are followed by a summary of the main point of the chapter — a quick review for your reference before you complete "Action Notes." Finally, there is space for writing some action notes describing how you'll implement the concepts presented in the chapter.

Use This Book As a Reference

ON-THE-LEVEL is designed as a practical guide for your use. You can absorb its information in many ways. Skim it, scan it, read parts or all of it.

Flip through the book. You'll find the chapter title at the bottom of each page. The topic discussed on the page appears at the top of the page. As you flip through the book, you'll get a good idea of its content, and you can pause to read when you come across something that interests you.

Use this book as a reference source any time you prepare for a performance discussion. It can provide guidance, moral support, ideas for improvement, or perspective on your own management or employment philosophy.

Turn to the Contents of this book to find the title and page number for each chapter, and where to find each action idea discussed in the chapter. This will save you time later when you know what you want to read and are in a hurry to find it.

INTRODUCTION

Sam manages an engineering department in a manufacturing orga-nization. He's been a technical specialist, a supervisor, and now is the manager of engineering — quite a career! Ask him what the hardest part of being a manager is and he answers without hesita-tion, "Talking with my staff about how they're doing. I guess I'm not comfortable being a 'judge.' A lot of these people have been my colleagues and friends for years. I'm afraid I usually avoid being direct and specific about what I think — whether it's compliments that might embarrass them or criticisms that might upset them."

Sara is an engineer in Sam's department. She is a senior project leader with some very specialized technical skills. Throughout her career she has believed that good communication with her boss is essential to her own current good performance and to her future career opportunities. But feedback from Sam has been sparse and mostly nonverbal. He simply hasn't given her much of a clue about his views of her performance.

"Well, the year-end performance review is coming up. Maybe I'll get some insights there," she thinks. However, the review comes, and it is rushed — sandwiched between other performance appraisals which, like hers, must be done before year's end. Sam's comments on the review forms aren't very specific and don't match the messages Sara has been getting from him on a day-to-day basis. Frustrated, she begins to spend more time sulking at her desk and complaining to her colleagues about Sam's poor management practices.

Both Sam and Sara are having trouble communicating with each other about performance. What can they do to improve the situation?

On-The-Level Communication: What Is It?

On-The-Level communication refers to direct, shared responsibility, output focused communication in the workplace. It is communication that is open, above board, honest, respectful and deliberate. Individuals communicate On-The-Level when they make a commitment to and take responsibility for working out problems together and understanding each other, and have the communication skills necessary to do so through *purposeful* discussion.

On-The-Level communication is not a solo performance. It is the responsibility of both manager and employee. If both make a commitment to honestly assess how well they now communicate and to thoughtfully apply the proven communication skills and guidelines presented in this book, they will make strides in setting goals, assessing performance, resolving problems, and planning for future work and development.

Principles of On-The-Level Communication

Communication is a complex interaction. To make it easier to learn and apply the principles of On-The-Level communication in your conversations, this book breaks On-The-Level communication concepts into skills and ideas. The following On-The-Level principles underlie the skills and ideas presented:

- Communication among people in an organization is going on all the time, whether they are aware of it or not. Everyone in the organization receives and delivers messages about goals, performance, careers and development.

- Unfortunately, these messages may not be consistently or clearly communicated. And, if people do not receive information directly, they rely on their own interpretations of nonverbal or ambiguous messages.

- On-The-Level communication — direct, deliberate, shared responsibility, output focused communication — is central to an organization's success. This is especially true in an information and service economy,

where people are the organization's most critical resource. When someone has something to say, or when someone has a need to know, it is critical that each person state his/her views or questions directly.

- On-The-Level communication *makes good interpersonal sense* as well. When information is on the table, problems can be solved and choices about future assignments or development actions, even disciplinary actions, can be made in good faith. Some information and feedback may be hard to deal with, but nothing drains energy and trust like half-truths and avoidance. Direct communication is an employee right and a management responsibility. It is also an employee responsibility and a management right. Some personal dividends of On-The-Level communication are a feeling of accomplishment and reduced stress on the job.

- Communication can't be direct unless both the manager and employee play active roles in making it that way. When the discussion concerns goals, feedback, tough messages, or development needs, performance communication is the shared responsibility of both parties. This means that whether you are in the role of manager or employee, you must be fully aware of how to make your communication successful. Communication skills in both roles must be strong and deliberately used. Conversations must be *output focused.*

- *Judgment and subjectivity* are integral parts of organizational life and are reflected in communication. Both the manager and the employee must be able to formulate and express valid judgments and opinions based on sufficient, accurate information. In fact, both the employee and the manager are paid to do just that. In the context of communicating about performance, however, people must also become aware of their biases and acknowledge them as they effect their own judgments and opinions.

- The employee performance and development cycle, regardless of organizational level, consists of five stages:
 1. Setting goals
 2. Observing performance
 3. Giving and getting feedback
 4. Delivering and digesting tough messages
 5. Development planning.

 Each is the topic of a chapter in this book.

- Effective On-The-Level performance discussions in all of these areas must be *human,* not mechanical or form driven. They require judgment and flexibility on the part of employee and manager. Each individual — manager and employee — inevitably has different communication skills and perspectives to bring to a conversation. Forms, guides, and other tools may be means to achieve On-The-Level communication, but they must never become ends. No form, policy, or procedure can ensure On-The-Level communication in your organization. Nor can a form, policy, or procedure interfere with it, if all parties understand and are committed to On-The-Level communication.

What You Can Expect

In ON-THE-LEVEL, we propose that direct, deliberate, output — focused, shared responsibility communication is a cornerstone of excellent performance and a good work climate. On-The-Level communication is important in every human interaction every day, including informal discussion. However, in this book, we focus on the planned discussions between employees and managers that formally establish, maintain, and develop the link between the employee and the organization. We provide guidelines, ideas, and examples to help you improve the quality, skill and honesty of your communication when, as a manager or an employee, you discuss performance and development.

On-The-Level communication may appear simple and seem like common sense, but it is often difficult and generally not common

practice. As you build your skill in this important area, be gentle with yourself and others when communication doesn't go well. Strengthening communication practices is part of life's ongoing work. In this book we are very sensitive to that fact, although we firmly maintain that both managers and employees can make dramatic improvements in the quality of their interactions through applying the principles of On-The-Level communication.

GOAL SETTING

In the last quarter of every year since he's been with the company, Bob, a staff accountant, has worked with his manager to prepare written objectives, thus satisfying the company's "management by objectives" policy. Typically, however, the written objectives have been only a small part of a dynamic goal setting process that Bob has used to become an outstanding performer.

Bob uses On-The-Level communication on the job. Whenever he receives a work assignment, his standard practice is to ask his manager to describe the results she's looking for. He also asks who will use the results, who will need to be informed about project progress, and what each project's priority is in relation to others. He makes sure he and his manager have a mutual understanding of what he's expected to achieve. He is the first to renegotiate those expectations when he notices a change in the organization's priorities or feels that a project needs to be redefined.

Bob doesn't like the wasted effort of redoing projects because goals and requirements aren't clear. He also knows that to be effective, his performance must be in sync with his department's direction. Most importantly he believes that it is his responsibility as well as his manager's to always clearly define what he's expected to contribute.

Bob, unlike some of his colleagues, has learned the value and benefits of establishing mutually clear goals.

Common Pitfalls When Setting Goals

It is difficult to manage, and have On-The-Level communication about performance, when expectations aren't defined and mutually clear. Yet many goal and objective setting systems that intend to do this don't work or aren't very effective. Some reasons?

There may be *too many objectives.* Tracking and managing them becomes as time consuming as achieving them.

Work may have proceeded with *no one truly accountable.* This is especially common when teams of several people work together to produce a complex product or service. These comments typify what is heard in these situations: "I don't have the authority," or "The other department didn't come through," or "The environment changed." These and other reasons cover up and excuse the fact that accountabilities are falling through the cracks.

Objectives may not say enough about the *qualities or measures* — the excellence criteria — of the expected results. When managers and employees don't have the same visions of what excellent results will actually look like, they may think they agree on goals but blissfully march to different drummers until they realize that they disagree on whether or not the objective has been achieved.

Objectives may define *activities and tasks instead of outputs*. Of course, outputs — results or accomplishments — are what the organization needs. Activities and tasks are means to an end — valuable only if they get the desired results. Activities should never be the main focus in goal setting.

Objectives may be *too wordy*. When objectives are wordy, they obscure what the performance expectations really are — the focus gets lost in the fine print. Wordy objectives confuse people and don't communicate expectations that are mutually clear and On-The-Level.

GOAL SETTING

Sometimes objectives and *expectations change, but the formal job description doesn't.* This can create an uncomfortable tension between what an employee is asked to contribute and how the employee's job is perceived by himself/herself and others in the organization.

Setting objectives and goals and developing job descriptions may be treated as *an intrusion, a formality, or a requirement* that occurs periodically and must be satisfied before the "real" work gets done. The heart of the planning process — direct, clear, On-The-Level communication — may be ignored or overlooked in order to complete forms and meet deadlines.

At the heart of mutually clear performance expectations are the answers to two questions:

1. What will be accomplished?
2. What will the accomplishment look like when it is excellent?

On-The-Level goal setting produces answers to these questions. It describes what an employee is expected to achieve — the output. It creates a common vision between the employee and the manager of what performance will look like at its best — the criteria for excellence.

Expectations — whether they're called "objectives," "goals," "targets," or "accountabilities" — should be clear, mutually agreed on, and renegotiated when necessary. If communication breaks

down during goal setting — or is incomplete — these are the likely results:

- Day-to-day pressures, miscues, mixed messages, and just plain forgetfulness divert the employee's energies in unplanned, low-priority directions. In these situations, "But I thought I was supposed to," or "I didn't think that was important anymore," become the sad refrains of befuddled employees, as equally befuddled managers scramble to justify the adjustments in budgets and deadlines that inevitably result from crossed goals.

- Follow up discussions tend to focus on problems, excuses, and clarifications. These discussions are likely to cause more anxiety than they would have if accountabilities were clearly defined and negotiated in the first place. Everyone — the employee, the manager, and the organization — benefits when there's agreement about what an employee's goals are and when the goals are clearly stated and understood.

It's not necessary to have a formal goal setting system, though many organizations do. What is important is that On-The-Level discussions about goal setting occur when appropriate and that agreement is reached about performance expectations. The logical time for such discussions may be at a crucial point in the annual business planning cycle, at the beginning of a new year, at the start of a new project, when organization priorities change, or when new opportunities or problems arise.

Action Ideas for Goal Setting

Three action ideas can help assure that goal setting in your organization is On-The-Level:

1. Define outputs and excellence criteria.
2. Keep job descriptions current.
3. Renegotiate goals as needed.

To implement these ideas successfully, both the manager and the employee must work together.

Action Idea 1: Define Outputs and Excellence Criteria

A useful goal statement has two components — an output statement and a list of excellence criteria. The first step in a goal discussion is to identify the outputs. Outputs are the accomplishments, products, and services — not activities — that an individual is expected to deliver to the work group, other departments, customers, outside agencies, and other groups.

Outputs should relate to the employee's ongoing job responsibilities and to the organization's current priorities. They should describe the accomplishments for which the employee will be accountable. By accountable, we mean responsible for achieving, troubleshooting when problems arise, and renegotiating with the manager when barriers are beyond the individual's resources or authority to resolve. Typically, outputs will be products, services, plans, decisions, or information.

These are some typical outputs:

- Department budgets — a plan
- Design for product Z — a product
- Technical advice — a service
- Control reports — information
- Business strategy — a decision

Output statements describe what is to be accomplished, not the activities needed to accomplish them. Why? These examples illustrate what may happen when activities rather than outputs are goals.

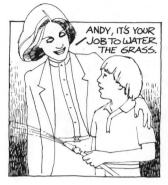

First a family situation. Mom wants Andy to take care of the lawn so she asks him to water it on a regular basis. Andy regularly waters the grass, but the lawn is beginning to look unhealthy. Does Mom really want the activity, grass watering? Or does she want the output, a healthy lawn — whether that means watering it often during a drought or never when it rains, mowing, fertilizing, and getting rid of weeds.

Clearly, a better charge is to describe the desired result, not the activity. Now it's Andy's responsibility to water the grass whenever it needs it, to recognize and talk to Mom about problems other than a lack of water that may be killing the grass, and even to stop watering the grass during rainy weeks. He's accountable for an output — a healthy lawn — whatever it takes to achieve it.

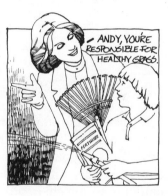

Now, a business example. The sales manager tells salespeople that their goal is to increase the number of sales calls. But will it be acceptable for Marion, a sales rep, to make more calls but not bring in more sales as a result of those calls?

GOAL SETTING

What the manager really wants is *new orders*. When the goal is stated to reflect that output, Marion has to assure that her sales calls are made to the best prospects and that her sales calls are high quality. She's got to deliver an output, not just complete an activity.

The first step in effective, On-The-Level goal setting, then, is to identify the accomplishment — the output to be achieved.

Identifying the output is not enough, however. What is a "healthy lawn?" What is "increased sales?" Individuals may interpret these differently. If goals are to be mutually clear, the manager's and employee's definition and vision of what constitutes a desirable output must match. In order to assure this match, it's necessary to describe the qualities that each output will have when it is considered excellent. Expected output qualities become excellence criteria. The excellence criteria for an output answer questions like these:

- What quality standards must be met?
- What people need to be involved?
- What relationships should be maintained?
- What quantities have to be achieved?
- What schedule is to be met?
- How accurate must the work be?
- Who will approve it?
- Within what budget must the work be completed?

Output	Excellence Criteria
A home goal . . . Healthy Lawn	• Green • No brown spots • Lawn depth of three inches • No weeds
A sales goal . . . New Orders	• Five per week • Over $100 initial order • Eighty percent reorder within 30 days • All sales documents completed and to home office within seven days of sale • Good relations with order processing staff maintained
A manager's goal . . . Budgets	• Approved by the end of the fiscal year • Require no more than two revisions • Use the company format • Costs at 95% of preceding year
An engineer's goal . . . New Product Design	• Meets needs identified in market study • Is producible in the existing plant with a maximum of $50,000 in capital investment • Is approved for market test by June 30 • Involves the purchasing department during design stage
An executive's goal . . . Strategic Plan	• Incorporates market research • Involves all department heads in plan development • Defines customer segments, opportunities, threats • Includes implementation plans • Approved by company president by August 30

A sales manager's goal . . . New Territory Operation	• Achieves projected sales volume • Is staffed with trained representatives • Includes a leased and outfitted new office • Implements effective communications between field and regional office

Identifying Outputs and Excellence Criteria for Delivering Services.

Outputs and excellence criteria may seem easier to write for projects or for situations where a product is produced than for situations where ongoing services are delivered. The format described above, however, works well for situations where the desired output is consistent delivery of quality service.

It is difficult to predict the many kinds of situations that call for a service-oriented response. This is precisely why a service performance goal needs to be described in terms of outputs, not activities. When service delivery is the performance expectation, state the overall type of service (the output) and elaborate by specifying the excellence criteria that distinguish good quality service. It may also help when discussing service goals to review the types of situations when it is particularly important to keep service goals in mind.

Here's an example of how discussing a goal in terms of an output helped in a service environment. Jane, a hospital director of patient services, was telling Tom, one of her employees, what to do with patient checkout procedures because there were many complaints about the service and the time it took. Each suggestion was implemented, yet problems persisted.

It finally dawned on Jane that she was responding to individual instances and not really getting at broader solutions that could reduce the time required to check out without creating new problems. She sat down with her manager and made the following statement: "You and your administrators are the closest to the

patients. I want you to do what it takes to assure patient-focused checkouts."

By stating the desired accomplishment, or output, Jane communicated to Tom, in a simple and straightforward way, what the service priority needed to be.

The balance of their discussion identified the criteria for Tom and his administrators to use in evaluating the ideas they might come up with. The requirements of a complete checkout were also discussed.

Here are the excellence criteria that Jane and Tom developed for a patient-focused checkout process:

- Patients feel it's quick and efficient.

- Unforeseen delays are handled so that patients don't feel inconvenienced.

- Patients get information they need for billing and insurance claims.

- There is an atmosphere of friendliness and caring.

- Checkout practices don't create problems for other departments.

Tom left the meeting understanding the priority as well as the other factors that would help him recognize good solutions. He didn't have a mandate to take specific actions, but that didn't matter. He and his people would do whatever was necessary to accomplish the goal, given the available resources and the ethical constraints placed on them.

Action summary

Communicating about performance — what is expected and whether expectations have been met — frequently breaks down because managers and employees have not developed and maintained a *common vision* of outputs and excellence criteria in goal setting. A simple format for defining goals such as the one shown previously can help assure that expectations are clear and On-The-Level from the start. Of course, both the manager and the employee must act together to develop and, when necessary, change the

vision of what goals, outputs and their excellence criteria, must be produced.

Specifically, as a MANAGER you can take the following actions:

- Describe the organization's priorities. Help each employee understand how he/she fits into the larger picture.

- Communicate your own goals to your staff. Their goals will need to support yours.

- Request a list of outputs and excellence criteria from each employee.

- Have a thorough On-The-Level discussion about the employee's target outputs and excellence criteria to be sure you have a common vision about job requirements. Ask questions when your expectations and the employee's viewpoint differ. This will help you understand his/her position and clarify the issue. You may want to revise your expectations based on a new understanding of what needs to be done.

As an EMPLOYEE, you can do the following:

- Ask your manager to describe the organization's current priorities and tell you about his/her own goals. Don't identify or become committed to your own goals until you really understand the bigger picture of what your manager and unit need to achieve.

- Write your own list of outputs and excellence criteria. Consider it a discussion draft for negotiation and fine-tuning with your manager.

- Thoroughly discuss the outputs for your job and the excellence criteria that define your job outputs with your manager. Expect your manager to have some different perceptions and goals. Be prepared to talk On-The-Level and willing to make changes that you and your manager identify so that you have the same view of what you're expected to achieve.

Action Idea 2: Keep Job Descriptions Current

Every job has — or should have — its role and place in the organization's structure. The role and place is often defined in a formal job description as a list of employee job responsibilities, duties, and areas of authority. Describing each job in these terms is important for determining compensation, showing how jobs relate to each other, and making hiring and career planning decisions. Thus, the job description establishes the boundaries of a job — what it does and does not include. It helps management and employees distribute the organization's work.

We recommend that at least once a year, the manager and employee review the formal job description. If current outputs, defined by excellence criteria, involve responsibilities beyond those listed in the job description, and if the changed responsibilities seem permanent, then initiate a request to change the job description to reflect the job's new scope.

In larger organizations, this may have to be done through the personnel or human resources department. However, a procedural constraint shouldn't prevent you from taking this very important action and may, in fact, assure a more thoughtful change.

In any event, keeping job expectations in sync with changing conditions is a key requirement of On-The-Level performance communication. When it doesn't happen, mixed messages and conflicting rewards can divert energy from important goals. This doesn't have to happen if job description reviews become a regular event.

Action Summary

When communication in your organization is On-The-Level, both the employee and manager must share responsibility for keeping job descriptions up to date.

- As a MANAGER . . . be alert to job changes that may alter the scope of a job. Obtain job description changes when they are called for.

- As an EMPLOYEE . . . monitor your job's require-

ments. If you feel they are changing substantially, talk with your manager about modifying the formal description.

Action Idea 3: Renegotiate Goals As Needed

Output targets and excellence criteria may need to be renegotiated in these situations:

- When organization or department priorities change.

- When external conditions change — this includes economic, regulatory, market, competitive, and technological change.

- When support expected from others does not occur.

- When unforeseen problems or opportunities arise.

When any of these happen, it is usually up to the *employee* to recognize the potential effects on his/her ability to deliver the target outputs. If it looks like the defined outputs will not be achievable under the circumstances, then he/she must renegotiate and solve the problem with the manager.

It is the *employee's responsibility* to initiate renegotiation of the outputs of his/her work, because he/she is responsible for troubleshooting and delivering his/her own outputs. If a situation changes or someone else doesn't meet a commitment, it's not a valid excuse for letting go of this responsibility. When problems and barriers require higher levels of authority for resolution, it is the employee's responsibility to ask for assistance. It is the manager's job to help address the issues that a stymied employee might raise.

Action Summary

Deliberate, direct, On-The-Level communication is the joint responsibility of manager and employee throughout renegotiations of goals. Specifically, managers and employees have these responsibilities:

- As a MANAGER ... it is important that you watch for signals that employee outputs need to be changed. Talk with your employees about their outputs and discuss the possible need to renegotiate outputs as soon as the need is apparent. Don't wait for a crisis.

- As an EMPLOYEE ... accept that you are accountable for achieving the outputs as defined by excellence criteria. Be the first to recognize when problems and issues beyond your capability and authority threaten your success. If you can't negotiate to receive the support you need, renegotiate the accountability or redefine the outputs well in advance of the due date.

Where Do You Stand?

Think about these questions. Your answers will help you identify where your goal setting practices most need improvement.

... in YOUR JOB:

- If you and your boss separately listed your ongoing job responsibilities, how much would the lists overlap?

- Think about the special contributions you are expected to make in the next year. If you and your boss separately listed these, how similar would the lists be?

- Think about one important contribution you are expected to make in the next six months. If you and your boss separately listed the criteria for excellence, how much agreement would you predict?

- How descriptive is the formal job description — if there is one — of what you are actually expected to do in your work?

- Have any of your goals changed in the past six months? If yes, are both you and your manager clear about the changes?

... as a MANAGER OF OTHERS:

- If you and your staff separately listed their ongoing job responsibilities, how much overlap would there be?

- If you and your staff separately listed the special contributions they are accountable for, how similar would the lists be?

- Think about one important contribution you expect one of your staff to make during the next year. If you and he/she separately listed the criteria for excellence, how much agreement would you predict?

- Think about one of the people reporting to you. How accurately does his/her job description (if there is one) reflect what you actually expect someone in that job to deliver?

- Think about one person who reports to you. Have any of his/her goals changed in the last six months? If yes, are you both clear about the changes?

Based on your answers, what do you most want to improve about your goal setting — the way you set goals for yourself or help others establish theirs — to make communicating about goals more On-The-Level?

The Main Point Is . . .

Effective goal setting assures that both manager and employee bring the same expectations to performance. It defines what productivity means for a job and provides a framework for observing, discussing, and troubleshooting performance later on. It is a key ingredient in the On-The-Level communication process.

The actions to use in On-The-Level goal setting are:

- Define outputs and excellence criteria.
- Keep job descriptions current.
- Renegotiate goals as needed.

Action Notes

What points do you want to remember from this chapter?

What action ideas will you use?

GOAL SETTING

ON-THE-LEVEL

PERFORMANCE OBSERVATION

For more than two months, Jim, a data processing manager, has been getting reports from several sources that Sandy, one of his new analysts, is abrasive and has been alienating several key clients. He asks her to come to his office and says, "Sandy, the rumor mill is full of comments about your abrasiveness with some of our key clients. What do you have to say for yourself?"

Taken by surprise, Sandy responds, "Jim, I've met all my deadlines and my work has been superior — you've said so yourself. What do you mean rumor mill? Who's talking about me that way? What evidence do they have?"

Unfortunately, Jim can't respond to Sandy's legitimate need to know specifics. He hasn't observed Sandy's work with their major clients. He was so upset about the negative feedback that he neglected to track down the source of the rumors or to get any specific observations from people who were affected.

Since he has nothing further to say, his feedback based on the rumor mill can have no positive impact on the quality of Sandy's performance. Since it appears that Sandy is unaware of — or unwilling to discuss — how clients view her behavior, her observations won't clarify the situation either.

What started as an attempt to raise and deal with a problem ended with bad feelings and confusion about what to do next because the necessary observations of Sandy's job performance were not made.

Common Pitfalls When Observing Performance

It is difficult to manage and have On-The-Level discussions about performance, when the appropriate performance observations are not done. Many performance discussions fail to produce mutual understanding or behavioral change because performance has not been adequately observed. Here are some pitfalls to avoid:

Frequently, managers and employees don't know what to look for in performance because they haven't set mutually clear goals. So, they can't make useful performance observations. Unless the manager and employee have the same *frame of reference,* behavior appears random, and the relative importance of the individual's actions or accomplishments cannot be assessed. When observing performance, it's important that both the manager and the employee know what is supposed to happen in critical performance situations.

A major problem in observing performance is managing *biases.* Both managers and employees filter what they see through their own personal values and stereotypes. These biases may interfere with their ability to assess behavior accurately.

Managers and employees often *rely on only one person's view* of performance — usually their own. Since performance is complex, several viewpoints (including the employee's) are often better than one for zeroing in on what are effective or ineffective outputs and actions. Several viewpoints are especially important in today's work environment where subjective goals, such as customer satisfaction, are growing in importance.

Managers and employees may *forget what they've seen.* They may also overemphasize or underemphasize the importance of observations based on whether they've made them recently, during crises, or many months ago. Generally, recent events are remembered more vividly and carry more weight in performance reviews than distant ones. It helps to write down your observations on a regular basis.

Often managers and employees *don't realize what it takes* to produce results. Results occur because employees perform in certain ways, using certain competencies and style. But results also depend on resources being available, other departments or people doing their jobs, management support, and other external factors. The manager, and particularly the employee who's responsible for the results, must be able to observe performance and manage change from this perspective.

PERFORMANCE OBSERVATION

As Jim and Sandy's conversation shows, good observation practices lay the foundation for effective feedback about performance. Without quality observation, you can't accurately evaluate your own or others' performance and you won't know whether performance should be maintained or corrected in order to meet goals.

Despite its importance, observation is often the weakest link in the chain of skills needed for On-The-Level communication.

Why? The complexity and unpredictability of day-to-day events in organizations make it difficult to observe and evaluate performance. What standards can you use? What do you look for? What is excellent performance? What competencies and style best accomplish important goals?

To overcome the complexity and seeming randomness of much work behavior, the employee and manager must develop the ability to identify patterns in behavior from which to draw conclusions about performance. As this chapter will show, behavior patterns do exist — even in the most frenzied environments. And these patterns can help or hinder performance effectiveness.

Observing performance to identify behavior patterns that effect outputs is a key skill in On-The-Level performance discussions. Without this skill, your feedback to others or yourself can be invalid, shallow, off target, and unconvincing.

Action Ideas for Observing Performance

Performance observation is a key responsibility of both the manager and the employee. The action ideas presented in this chapter can help assure that your observations result in constructive, useful feedback — feedback that will help you or others produce the outputs described in your performance goals:

1. Look for outputs, competencies, and style.
2. Manage your biases.
3. Watch for specifics.
4. Develop a broad perspective.

Action Idea 1: Look for Outputs, Competencies, and Style

It is impossible to know or analyze everything that happens on the job. But it is important to observe directly — or by tracking results or asking questions — the factors that most affect an employee's current performance and his/her long-term ability to get things done in the organization.

Answer these three questions to get valid data about performance:

- Are the outputs on target?
- What competencies are helping or hindering effectiveness?
- Does style aid or interfere with quality performance?

Are The Outputs on Target? Outputs are the results of work produced by an employee. Outputs may be difficult to observe and assess for the following reasons:

- Some outputs are intangible. For example, strategies and positive employee relations are difficult to observe.

- Some outputs are subject to diverse interpretations. For instance, a good design, a quality budget, a quality product, or a more efficient plant are all subject to individual interpretation.

- Some outputs cannot be measured with existing measurement systems. For example, number of referrals or increased number of bank services per customer may be difficult to quantify.

If the goal setting process is effective, the excellence criteria will guide observation and provide a measure for judging performance by both manager and employee. When this happens, observations can focus on the extent to which excellence criteria are being satisfied. The manager and the employee can quickly scan performance, look for evidence that outputs are on target, pass over extraneous or low-priority behavior, and quickly cull what they need to talk about in a feedback discussion. Performance observa-

tion is easy if the goal setting homework was carefully done at the outset.

If the goal-setting process is ineffective, the manager and employee probably didn't agree on the outputs (goals) and excellence criteria for work. When their frames of reference differ, it is difficult for them to reach the same conclusions about performance when they later meet to discuss it.

What Competencies Affect Performance Quality? Competencies are the key personal skills and knowledge that enable individuals to perform their work. There are five general competency categories to watch for as you monitor and manage your own or others' performance:

1. Thinking skills: These include abilities to take the larger perspective and issues into account, to analyze information, and to recognize priorities.

2. Business knowledge: This includes understanding the organization's strategy, goals, policies, and structure and the industry and environment of which the organization is a part.

3. Interpersonal skills: These are the skills needed to work with people, develop and maintain work relationships, communicate, and manage conflict.

4. Technical knowledge: This is the ability to use the tools and concepts of the technical or specialty area in which you work.

5. Physical skills: These include such qualities as strength, dexterity, and manual skills.

Employees often fail to produce expected outputs and reach goals because they do not have the competencies to achieve them. One challenge in observing performance is to identify when skills and knowledge are major aids or barriers to success. Ask yourself: What knowledge and skill are required here? When I am (or when my employee is) in a key performance situation, what do I (or what does he/she) do? What can I deduce about the strength of skills and knowledge from the actions taken? Specific examples of what you or others did in a situation can provide clues that will support the feedback and conclusions you communicate later on.

Does Style Affect Performance Quality? No one works in isolation. Individuals must collaborate with, influence, provide information to, and seek information from others. They must also use appropriate methods to manage information. How individuals work with others and with data — their style of working — can affect the following:

- Work quality
- Work timeliness
- Team spirit or work climate
- Long-term trust within or across groups
- How others see the individual's career options
- The willingness of others to delegate work or provide future opportunities

An individual's work style may have a persistent positive or negative effect on the overall productivity, trust level, or climate of a work group. Work style may also affect people in other parts of the organization. Finally, work style may actually threaten an individual's career options.

When an individual's work style affects his/her current performance or when it threatens to jeopardize future assignments, it is a legitimate and important topic to address during a performance review. This makes it an important target for observation as well, even though it may not be something that managers and employees plan to observe.

It helps to remember that when you make a reference to someone's style, all you are doing is making a *generalization* about a pattern of behavior you have observed as it effects outputs. Style observations usually start with a conclusion such as "Jane is proactive," or "Victor is negative." Often these conclusions about work style contain descriptive words and phrases like these:

participative	directive
analytical	intuitive
task oriented	people oriented
initiating	responding
conservative	experimental
expressive	reserved

theoretical	practical
competitive	collaborative
reflective	active
systematic	unstructured
attentive	talkative
positive	negative
fixed style	versatile style
quick response	measured response
detail orientation	broad outlook
personal focus	team focus
screens information	shares information
smooths conflict	confronts conflict

Unless you question them and dig deeper, labels like these can become self-fulfilling prophecies. Answer these questions to help you assess the role that style plays in performance: What does the individual actually do in situations where a certain style occurs? Does the particular style affect performance, work relationships, or positioning in the organization seriously enough to warrant a discussion?

By observing behavior *patterns across situations,* you'll be able to answer these questions and validate or refute generalizations about work style that may affect an individual's current or future ability to perform.

Action Summary

Both manager and employee must know what to look for when observing performance. If both have observed outputs, competency levels, and style, then performance discussions can be focused and based on actual events and examples.

As a MANAGER, these are some steps you can take to observe outputs, competencies and style:

- Periodically review the employee's list of outputs and excellence criteria. Be alert for situations where results should occur. Stop, look, and recognize what is happen-

ing in those situations. Look for patterns that define individual work style.

- Assess whether there is a style or competency explanation for performance. Is the individual effective or ineffective because of how he/she works? Because of what he/she knows or is able to do? Look for patterns across several situations before you draw any conclusions.

Here's what you can do as an EMPLOYEE to assure that your outputs, competencies, and style are an asset:

- Regularly review your target outputs and excellence criteria. Be alert for situations where planned results should occur. Ask yourself if how you are working is appropriate for the tasks and people involved. Look for patterns that define your work style.

- Revise the excellence criteria for outputs that you identify during goal setting if they don't seem to be the critical ones. Don't wait until your formal review or your next goal setting meeting.

- When your performance is exceptional (better or worse than planned), determine if the reason lies with your style or with your skills and knowledge. Were you effective or ineffective because of how you worked (style), or because of what you knew (knowledge) or were able to do (skill)?

Action Idea 2: Manage Your Biases

Personal values, viewpoints, and preferences can distort what managers and employees see when they observe performance. Although there is no such thing as totally objective observation, it is important to be able to recognize and control these distortions when they occur. The four biases that are most common in performance review situations are haloing, stereotyping, identifying with, and projecting.

PERFORMANCE OBSERVATION

Haloing. The positive and negative general reactions we have to others (or ourselves) can affect how we interpret what happens in specific situations. Psychologists call this bias the halo effect. It refers to the "mental glare" that blocks our ability to see actions that don't support overall conclusions. Sometimes the glare casts a positive light, illuminating positive accomplishments and shadowing problem areas. Sometimes the glare is negative, illuminating only faults and mistakes.

No one is always good or bad, right or wrong. If you catch yourself thinking about someone in extremely positive or negative terms, stop and correct any distortions you have. You won't eliminate strong positive or negative reactions to people, but you will be able to keep those reactions from biasing what you observe.

Stereotyping. People make judgments about others from their earliest contacts with them. Individuals' physical appearance, mannerisms, age, sex, and race can affect how others evaluate them. Stereotyping occurs when beliefs about a class or group of people (beliefs which are not based on observing performance) affect how an individual's performance is assessed. Stereotyping can lead people to expect more or less competent performance from others,

to exaggerate their strengths and weaknesses, or to notice only behavior that fits the stereotype.

Judgments about performance should, of course, be relevant to

the job and the job environment and must be based on what individuals actually do. They must not result from preconceptions or predictions that have no basis in fact.

Everyone prejudges. It's part of being human. But prejudgments have no place in performance assessment. It is vital to recognize any stereotyping tendencies you may have, to know the people and situations your stereotypes may affect, and to focus your observations as objectively as you can on actual performance and its results. Not only does everyone have a right to expect this kind of treatment, but there may be ethical and legal implications to contend with when stereotyping prevents accurate performance observations:

Identifying With. People are often attracted to others who share their values, style, or background. They may identify with others who are similar, leading them to think, for example, that "Chris is just like me." People who are "just like me" may get favored treatment. In the same way, a person whose values and approaches are dissimilar ("not like me") may get unfavorable treatment.

"Just like me" and "not like me" observations may help you choose friends, but they must be set aside in performance assessment. The task in observing performance is to determine if outputs are being achieved and to pinpoint the competencies and style that are supporting or interfering with effectiveness. Be careful to keep your performance observations objective when observing people you identify with.

PERFORMANCE OBSERVATION

Projecting. Projecting affects our assessments of what people do and accomplish. It occurs when we make assumptions about the reasons people do what they do and then judge their actions in terms of those reasons. In projection, the reasons come from the observer (the movie projector), not from the other person (the movie screen). No one can say with certainty why people behave as they do. When someone attempts to supply reasons and motives for another's actions, the conclusions reached often say more about the observer than the performer. Don't project motivations on performance you observe without validating them in On-The-Level discussion.

Action Summary

Observing performance requires work, focus, and energy. It may seem easy to draw on personal biases and assumptions and use haloing, stereotyping, identifying with, and projecting — to supply performance data that day-to-day observations should provide. Unfortunately, creating data by using these practices, instead of direct observation, can cause problems in feedback and review discussions. Observations must be the basis of On-The-Level communication about performance. For both managers and employees, observations should be as bias free as possible.

As a MANAGER, you can and must manage your biases when observing performance. Here are some tips:

- Ask yourself how you generally feel about each of your employees. Whom do you view positively? Negatively? Think about each person, examining how you feel about increasing his/her job responsibilities, recommending him/her for promotion, and delegating important work to him/her. If you feel positive, make a mental list of reasons why. If negative, do the same.

Finally, ask yourself if your overall impressions and evaluations are biasing how you see day-to-day performance.

- Get other perspectives on your employees' performance. Ask these questions: "What did you see happening in that situation?" "What was effective?" "Not effective?" Listen especially for observations that do not agree with yours.

- Listen to how you talk to yourself about each person who works for you. Be alert for haloing (having a general positive or negative impression), stereotyping (letting your beliefs about a class or group of people affect how you see an individual), identifying with (evaluating an employee because he/she is or is not just like you), or projecting (drawing conclusions about someone's motives). Tell yourself to look at the facts you observe rather than letting your biases prevail.

EMPLOYEES must manage biases as they affect their performance observations. Here are some tips:

- Recognize that your biases will — and do — affect your observations and judgments about your outputs, competencies, and style. Is an overly positive or negative self-perception (haloing) affecting your ability to see what is really happening in situations? Do you ever lapse into stereotyping yourself? Here are some examples: "People expect me to behave this way." "I'm a woman." "I'm a minority." "I'm over 60." "I'm less educated." "I'm more educated." Objective self-observation is at least as important as good observation on the part of management. Perhaps it is more important, because you are in a position to observe yourself 100 percent of the time!

- Whenever you can, get other perspectives on situations and your role in them. Ask these questions: "What did you see happen in that situation?" " What did you see me do well?" "What could I do next time to improve the

quality of my work, how I worked with others, or what I accomplished?" Ask for specifics — time, places, situations, actions. Ask for honest, complete observations. Listen to them, even if you don't agree with the observations or conclusions. Later you may choose to disregard what you heard.

Action Idea 3: Watch for Specifics

The most common communication pitfall in giving feedback to others or yourself is being too general. This can take the form of exaggerated descriptions such as "terrific," "great," "horrible," "good," generalizations about personality such as "you're a failure," "you're a star," or global performance ratings such as "he's a 1," "she's a 3."

Generalizations are appropriate when they are supported by *specific examples* of behavior or results that you have observed. They are never acceptable when unsupported by observations and presented as the only feedback in a performance review.

Action Summary

Both the manager and employee are responsible for observing specifics about job performance to keep performance discussions On-The-Level.

Here are steps you can take as a MANAGER to improve your performance observation skill:

- Watch what the employee does, how he/she works, what the effects are on others, and what is accomplished. Focus on specifics. You'll be able to draw on them to support your conclusions about overall performance.

- Write down what you've observed the employee do and accomplish. It's easy to forget details that may be valuable discussion points during formal performance reviews.

- Never generalize about performance unless you have several examples from your own or others' observations to support your conclusions. These examples should be typical, not exceptions.

- Avoid making sweeping personality assessments such as "you're a failure."

The EMPLOYEE's role in observing performance specifics includes the following:

- Think about the opportunities you've had to make important contributions in your work. Mentally review what you did in these situations, the effects your behavior had on others, and what you accomplished. Make a note of the competencies and style that produced or interfered with excellent output. You will be able to use your examples to illustrate your conclusions in the formal performance review and informal performance discussions.

- Don't generalize about your performance unless you can support your conclusions with specific examples from your work.

When managers and employees meet in formal performance reviews, all general feedback must be supported by specific examples. Employees have a right to know why managers evaluate them as they do. They also have an obligation to monitor their own performance — without bias.

Action Idea 4: Develop a Broad Perspective

Performance results do not depend totally on what individuals do. What individuals do has a major impact on organization effectiveness, but it is not the whole story. Other factors affect outputs. For example, the actions of people in other departments, the availability of resources, and other external conditions all affect an employee's ability to achieve goals.

PERFORMANCE OBSERVATION

Because outputs and accomplishments depend on an interplay of many factors, some beyond the control of the individual, you must develop a *broad perspective* from which to identify the important elements that affect job performance.

Does this seem like an impossible task? Are there too many things to observe and too many potential excuses for not accomplishing goals? Not if you follow two important ground rules when observing and evaluating performance: (1) individuals must be accountable for their outputs and (2) the organization must provide appropriate support. Under these rules:

- Individuals are held accountable for recognizing and resolving problems that may affect performance when they occur.

- Employees are expected to recognize problems that affect performance before they become crises. If the problems are beyond their authority, they must bring them to the manager for joint problem resolution, support, or renegotiation.

As the person responsible for accomplishing a goal, the employee must detect and resolve problems. This does not take the manager off the hook when problems call for higher authority or goal renegotiation. But the employee must develop and maintain a broad perspective to monitor all the conditions that may affect his/her ability to meet output commitments.

Action Summary

As a MANAGER, your role in developing a broad perspective from which to observe performance is:

- Hold your employees accountable for achieving their goals. If problems occur that an employee does not have the authority or resources to resolve, you must provide support or renegotiate the goal.

As an EMPLOYEE you can take these actions to develop a broad perspective:

- When your goals are in jeopardy, review what you have done, your own competencies and style, the resources available to you, and what others have done or not done. Identify what needs to be done to turn the situation around. You may need to think beyond yourself and your job.

- Go to your manager or someone else if you can't or don't have the authority to resolve problems yourself. Do this as soon as you realize the problem is beyond your control. Don't wait until the end of the year or until the manager notices that a problem exists.

Where Do You Stand?

Think about these questions before you read further. Your answers will help you identify where your observing performance practices most need improvement.

. . . in YOUR JOB:

- When you observe your own performance, do you focus on the following: How well am I achieving my outputs? What strengths and weaknesses do I have in my skills and knowledge? What is effective and ineffective about my style of working with people or information?

- Is it easier for me to assess and discuss my strengths or my weaknesses? How objective am I when reviewing my own performance?

- When I draw conclusions about my own performance strengths and weaknesses, can I cite specific examples to support your conclusions?

- Do I feel responsible for accomplishing my goals? Do I own them and see my goals as a performance contract?

- When my goals are in jeopardy, what do I do? Ignore problems? Feel out of control and let the goals slide? Or,

do I try to resolve problems and, if necessary, get help from my boss or others who have more resources or authority?

. . . *as a MANAGER OF OTHERS:*

- When you observe the performance of people reporting to you, do you focus on the following: How well do employees achieve their outputs? What strengths and weaknesses do they have in their skills and knowledge? What is effective and ineffective about their style of working with people and information?

- Think of three people who report to you. For each, is it easier to assess and discuss strengths or weaknesses? Do you have any personal biases that may affect your objectivity in reviewing any of these people?

- When you draw conclusions about others' performance strengths and weaknesses, do you cite specific examples that you or others have observed to support your conclusions?

- Do you encourage your employees to own their goals? Do you provide the resources and authority they need to get things done themselves?

- Do you encourage individuals to recognize and resolve problems early, or do the people who work for you come to performance reviews saying, "I didn't meet this goal because of factors beyond my control?"

Based on your answers, what do you most want to improve about your own performance observation practices — observing yourself or others — to make them usable in On-The-Level discussions?

The Main Point Is

Managers and employees must be able to objectively observe patterns in performance, distinguish effective from ineffective actions, and determine whether the cause of problems is within or beyond an individual's control. The quality and effectiveness of feedback discussions depend on how skilled both the manager and employee are in performance observation.

Use these four action ideas to sharpen your performance observation:

1. Look for outputs, competencies, and style.
2. Manage your biases.
3. Watch for specifics.
4. Develop a broad perspective.

By taking these steps, you'll be able to effectively observe and communicate On-The-Level about performance.

Action Notes

What points do you want to remember from this chapter?

What action ideas will you use?

PERFORMANCE OBSERVATION

GIVING AND
GETTING FEEDBACK

The 18 months Yvonne was in the marketing department were hectic ones for her. She had to learn a lot in a very short period of time and she received very little encouragement or feedback from her manager. She had developed a strategy for knowing where she stood by interpreting the "hidden meanings" in her boss's comments, watching how projects were assigned, and trying to figure out why she was invited to some meetings and not others. Eventually, she concluded that her boss didn't think much of her performance and decided to take a job with another company.

Yvonne's resignation and her reasons for leaving caught her boss off guard. He had thought her work was outstanding and had even told a number of his colleagues that he saw a bright future for her in marketing management.

Yvonne left feeling unappreciated, and her boss felt like he had been taken advantage of. How could these two people have gotten so far off track?

Common Pitfalls When Giving and Getting Feedback

Feedback discussions are a challenge for both the sender and the receiver of performance messages. Here are several pitfalls of performance feedback discussions that may cause problems:

Senders may fear that giving feedback will *backfire.*

Feedback receivers may fear that there is *more to the message* than what is said.

ON-THE-LEVEL

Most of the time, both the manager and the employee *treat feedback as a management responsibility. In reality,* it is a joint responsibility of both parties. Feedback should be solicited by the employee to help achieve outputs and meet excellence criteria, as well as volunteered by the manager.

Perhaps because they seem more active, the expressive communication skills (especially concluding and describing) are directly associated with good feedback. Yet, the *receptive communication skills* (observing, listening, and empathizing) set the tone and climate for success in performance discussions, and the manager, as well as the employee, must use them.

Many people approach performance feedback discussions by *following a step-by-step procedure.* They fill out the forms, get sidetracked by games during the discussion, and never acknowledge the human side of the process. These people never achieve On-The-Level communication.

GIVING AND GETTING FEEDBACK

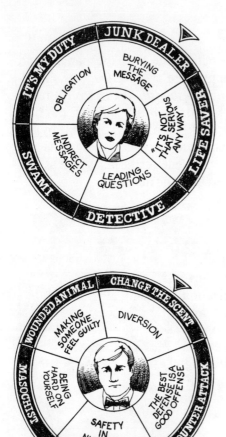

Feedback senders and receivers frequently get caught in *communication games* that diminish the quality of the feedback or destroy its effectiveness. Feedback senders may play games to avoid delivering tough messages. Feedback receivers, too, play communication games in order to avoid getting or acting on the message.

Feedback discussions are an intense form of communication for both the manager and the employee. On one hand, the manager needs to communicate conclusions about performance — about outputs, competencies, and style. In order to do this, he/she must observe behavior, draw conclusions from observations, prepare to support conclusions with data, and then communicate the feedback constructively and without game playing.

The employee, on the other hand, wants to know where he/she stands, but may find some or all of the feedback hard to take. He/

she must listen, clarify the feedback, observe his/her own behavior, describe the observations, and then make a commitment to appropriate actions.

On-The-Level feedback discussions are necessary for successful performance reviews. When effective, these feedback conversations evolve out of shared responsibility, employ the deliberate use of communication skills, are output focused, and direct. When not managed well, these discussions can damage the communication climate and make it even more difficult to communicate in the future.

Action Ideas for Giving and Getting Feedback

These six action ideas can make feedback discussions direct and On-The-Level:

1. Know what's in it for you.
2. Strengthen your feedback skills.
3. Organize your thoughts for feedback.
4. Avoid communication games.
5. Remember the human element.
6. Focus on outputs, competencies, and style.

These action ideas can help you improve your performance feedback practices and reduce fears and pitfalls. Suggestions and tips alone, however, cannot change the fact that feedback discussions are hard work. The action ideas will be useful only if you do the following:

- Decide you want to be good at feedback communication. Giving and receiving feedback is often difficult. It is important to be clear about what the payoffs for improving your practices will be. If you don't want to improve, action ideas are useless.

- Use good feedback discussion practices whenever you can. Many people are not as good at feedback discussions as they could be, and they expend a lot of energy

avoiding opportunities to give and receive feedback. Opportunities to practice and improve your skills exist at home, with friends, and with colleagues. Try out new skills and approaches whenever you can, on and off the job. In time, you'll notice great improvements in your comfort in feedback discussions, in your competence, and in the results you get.

Action Idea 1: Know What's In It for You

Giving and getting feedback, whether it's positive or negative, takes work and may provoke anxiety or stress. Thinking about the benefits and long-term payoffs of successful communication can help put any short-term discomfort into perspective.

The quotes below illustrate some of the payoffs for giving quality feedback:

- "Giving feedback helped me coach Fred. He wasn't as effective as I thought he could be in his formal presentations. My feedback about his skills and my follow up tips really helped him develop a new level of confidence in this area. I felt very rewarded by his growth and increased confidence." The payoff? The satisfaction of helping someone develop.

- "I feel people have a right to know where they stand. Giving feedback helps me fulfill my obligations in this area. I really felt good about myself, for example, when I worked with Jan to resolve a performance problem. She took responsibility for improving the situation. I felt rewarded because I fostered and respected her responsibility to manage her own performance." The payoff? Feeling you are managing with integrity and in a way that exhibits respect for others in the workplace.

- "I really need to get problems off my chest and don't like holding them in. I used to avoid giving feedback and wound up taking problems home with me every night. No more. Being On-The-Level really relieves my burden, and problems get resolved faster. I'm commit-

ted to keeping issues in the open where we can deal with them as soon as they occur." The payoff? Keeping a clean slate.

- "People and their achievements are the key to productivity in my company. Feedback discussions and performance reviews help keep my staff focused on their responsibilities. By managing people well, I assure performance that shows results on the bottom line." The payoff? Productivity and bottom-line results.

- "Since I've become a manager, I've begun to think about the impact my comments have on those who work for me, so I've been working to improve my communication skills. I think my family, friends, and colleagues are benefiting from my improved abilities to listen, ask questions, empathize, and say what I think. Just as important, I feel more confident in difficult communication situations both at home and at work." The payoff? Improved communication skills and confidence in all important relationships.

Feedback has long-term benefits for those receiving it, too, as these quotes illustrate:

- "I have a better idea about what I have to do to improve myself when I know how my boss sees the quality of my work and my effect on others." The benefit? Learning and personal development.

- "When my manager gives me feedback, I try to support open communication by listening as nondefensively as I can. I've learned that by listening and appreciating her efforts to give me feedback, I am helping to create a good work climate." The payoff? Improved work relationships.

- "I'm usually much harder on myself and my performance than my boss. If I don't ask for and listen to feedback about how I'm perceived, I think the worst! Being sure I get feedback saves me a lot of wasted energy." The benefit? Putting fears to rest.

- "It's easy to lose perspective as I face day-to-day pressures. Performance reviews help me refocus on the key requirements of my job. They help me to be more effective." The payoff? Improved productivity.

- "I used to think my manager was responsible for good communication with me. When he didn't initiate feedback discussions or talk to me about what he expected, I complained to my friends and waited for him to take the first step. I'm not sure why I never thought of this before, but it makes sense that the employee has some responsibility for communication, too. Now, I'm working on initiating discussions, asking questions, and making my opinions known. Interestingly enough, some of this behavior has spilled over into my home and personal relationships. I've still got a long way to go, but I'm less a victim in all phases of my life since I started working on my communication skills." The result? Improved relationships at and outside of work.

The long-term payoffs of good feedback discussions can more than offset the short-term discomforts. These broader benefits can be incentives for employees and managers, helping each get through any difficult aspects of the feedback discussion.

Action Summary

The implications of this action idea are clear. As a MANAGER, you must do the following:

- Have good personal reasons for wanting to give feedback. No matter what your reasons — helping, performing with integrity, keeping a clean slate, assuring productivity and results, improving communication skills and results in all phases of life, or something else — a belief that good feedback discussions are personally rewarding will spur you to initiate feedback communication.

- Think about the long-term payoffs when you feel short-term stress.

As an EMPLOYEE, you also have a stake in developing your feedback practices by paying attention to the following:

- You must believe that there are rewards for participating in a high-quality feedback discussion. The rewards may include learning, improving work relationships, reducing fears about how performance is viewed, improving productivity and work focus, and improving communication skills in general. Use this list of long-term benefits as an incentive to help you through periods of stress and defensiveness.

Action Idea 2: Strengthen Your Feedback Skills

Both the manager and the employee give and get information during feedback discussions. Both, therefore, must be adept at all the skills that support effective feedback communication. Six skills are particularly important. Three of them — observing, listening, and empathizing — are receptive skills. That is, the person using them must be in a receptive, nonevaluative frame of mind. The other three — questioning, concluding, and describing — are expressive skills. The person using them must be in a proactive, risk-taking frame of mind.

The receptive and expressive skill groups represent two entirely different ways of thinking and operating. Yet both are critical to complete, effective, On-The-Level feedback communication — and are active forms of communicating.

Most people think only of the expressive side of feedback and see it as the manager's responsibility. In fact, *both the employee and the manager* must observe, listen, empathize, question, draw conclusions, and describe observations. If either person is weak in the receptive or expressive skills, the quality and openness of the feedback discussion inevitably suffers. For both manager and employee, the ability to shift gears from the receptive role to the expressive role — and back again — is part of being effective at feedback communication. In order to do this, both must be skilled in all six areas:

Observing. Skill at observing is necessary for On-The-Level performance discussions. (See Chapter Two, "Performance

Observation," for many ideas about effectively observing your own and others' performance.)

Listening. Skill at listening is vital throughout the feedback discussion. It assures that all data gets on the table and that any difference of opinion is not the result of misunderstanding the other party's viewpoints. Good listening and paraphrasing also help establish interpersonal respect and trust, which makes it easier to freely discuss tough issues. During a feedback discussion, the manager and the employee must put aside their personal opinions, feelings, and reactions in order to hear and understand the other party's point of view. Then, to close the communication loop, each must be able to paraphrase the other's observations and conclusions.

Empathizing. Both the manager and employee bring feelings, emotions, values, needs, and opinions to feedback discussions. The manager or employee may have anxieties about giving or receiving feedback. Some of the feelings and values may be related to the specific issues discussed in the session. Discussions of outputs, competencies, and style are never emotionally neutral!

Listening for and acknowledging feelings as well as information can help remove any personal blocks or defensiveness that may threaten the feedback discussion. Empathizing occurs when, as a manager or employee, you do the following:

- Ask for information about feelings: "How do you feel about that?"

- Share your own similar experiences to illustrate that you know what the other person is experiencing: "What you're experiencing is the same concern I had when I came to this department. It was overwhelming for me."

- Make statements that show you understand feelings and values: "I realize it's hard to get this feedback."

- Avoid evaluating feelings and values: "You shouldn't feel that way."

Empathy is an essential skill because feedback communication is a human process, not a mechanical one. Acknowledging and understanding values and concerns can help raise the comfort level between manager and employee. It also helps establish trust and

respect. In this climate, issues, problems, and successes can be thoroughly discussed.

Questioning. It is impossible for the employee or manager to completely anticipate what the other needs to hear. Both must rely on probing questions to assure that thorough communication has occurred and that each understands the other's observations and point of view.

Questioning, at its best, requires that you:

- Be interested in what the other person is saying and show that interest through facial expressions and posture.

- Ask open-ended questions that begin with words like what, tell me, and how, rather than with words like do and don't. Do and don't questions look for yes or no responses and close off communication.

Questioning uncovers information so everyone can see it. Taking time to question gives both parties an opportunity to explore observations and conclusions. It also gives the questioner time to relax, reduce tension, and minimize the risk of jumping to early conclusions about where the other person stands.

Concluding. One major purpose of feedback communication between a manager and employee is to assure that work is on target. In order to do this, both the manager and the employee must draw conclusions about performance. Drawing conclusions requires both parties to make evaluations. The manager, of course, is paid to draw conclusions about the performance of those who report to him/her. It's important to realize, however, that each employee is also responsible for continuous self-evaluation and for drawing conclusions about his/her performance, especially in key accountability areas.

Drawing good conclusions means that you:

- Assess the quality, timeliness, and appropriateness of behavior across a variety of situations.

- Identify strengths and weaknesses in outputs, competencies, and style.

GIVING AND GETTING FEEDBACK

- Control biases that may affect evaluations. These biases include haloing, stereotyping, identifying, and projecting, which were discussed in Chapter Two.

- Determine whether successes and problems are the result of the employee's behavior or of factors outside his/her control.

Managers must draw conclusions in order to decide what to give feedback about, how to rate overall performance, what additional work to assign, and where development and special support are needed. Employees must continually draw conclusions about their own performance in order to know what aspects of performance to improve, develop, and continue and to be full partners with managers in performance discussions.

Drawing conclusions is an expressive skill that requires making judgments and taking some risks. Both judgment and risk-taking in performance discussions are necessary to keep individual performance aligned with the priorities of the organization.

Describing. To keep discussions On-The-Level, both the employee and manager must be able to verbalize what they have observed and what they are thinking. They must be able to describe their observations using concrete examples. Whether you are a manager or an employee, you need to:

- Describe the actions and results you have observed.

- Be specific about when and where actions took place, what was done, and what the effects were. This statement is an example of being specific: "When X happened, I saw you do Y, and the results were Z."

- Describe reactions and personal feelings about the behavior and its results.

- Tailor the timing and amount of feedback you present to fit the individual and the review situation.

Specific, concrete examples provide significant support for any conclusions that the manager and employee disagree about or for conclusions about superior or problem performance.

Both manager and employee must anticipate the areas where

specific examples will help the communication process and should be prepared to discuss those specifics during the performance review.

Action Summary

Six feedback communication skills — observing, listening, empathizing, questioning, concluding, and describing — are important tools for managers and employees to use in On-The-Level performance review discussions. Whether you are giving or receiving feedback, it is important to continually work at refining and mastering these skills. It is also important to balance the receptive and expressive skills. Performance discussions can only be as good as the communication skills of those involved.

Both MANAGERS and EMPLOYEES can work to improve feedback skills by practicing the following:

- Identify the skills — observing, listening, empathizing, questioning, concluding, describing — you want to strengthen or use with greater comfort and assurance.

- Look for daily opportunities to improve these skills so that the next time you review your own or an employee's performance, you'll be ready to play a stronger role in the discussion.

Action Idea 3: Organize Your Thoughts for Feedback

Those giving feedback often have difficulty organizing their thoughts. And the person receiving feedback may be confused by what the feedback giver is saying, especially when the feedback is given in a manner that is difficult to follow. Both the person giving feedback, as well as the person receiving it, can benefit from having a structure to follow while giving or actively listening to feedback. When you give feedback, you can structure your message by answering these questions:

GIVING AND GETTING FEEDBACK

What did I see that caused me to want to give feedback? At this point, describe only your observations, without any conclusions, in order to establish the focus for your feedback. After you describe what you have observed, you can use questions and active listening to explore what the person receiving the feedback has observed. For example: "When you were with the customer, you told her what to do before she had explained her problem. She got angry and called me in to work with her instead."

Why are the observations I described important? This is the evaluative part of the message. It requires conclusions about the observed behavior. It focuses on the implications and effects of the observed behavior. For example, "Not listening caused the problem to escalate. She became more demanding, and we had a crisis. Since she's a key buyer for one of our best clients, this could have ripple effects."

What would I like to see happen? This part of the message is a chance to describe, in positive terms, what you would like to see happen in the future. This is an opportunity to express the results you expect and the criteria for excellence you have in mind. (See Chapter One on communicating about goals.) It also might be a time for you to engage in a problem-solving discussion in which you use your questioning skills. For example: "What you do in the early stages of discussions like these can make a major difference. The goal is to understand the problem, maintain our relationship, and prevent escalation of negative feelings. Let's talk about what you could have done to get these results in that situation."

This structure works when you want to give positive feedback, feedback about problems, or feedback about constructive changes you want to see.

It is also a useful structure for the person receiving feedback because it helps organize the feedback someone else is trying to give. The receiver can ask the questions listed above and in doing so help the person giving feedback communicate his/her message in a complete way. For example: "What did you observe? What were the effects as you saw them? What do you think were some better options?" Asking questions to help organize feedback also helps the receiver stay more involved in and share responsibility for the process of communication.

Action Summary

As a feedback giver, you can make your feedback more effective —
and more useful to the receiver — if you structure it. A feedback
receiver can make sure that the feedback giver is relaying all the
important messages by listening for key information and asking
questions if that information is missing or confusing.

As a feedback GIVER, structure your feedback so that it answers
the following questions. As a feedback RECEIVER, listen for the
following information:

What did the feedback giver observe in the situation that
prompted a decision to give some feedback?

Why is this information important for the receiver to know?

What does the feedback giver think would improve the situation
in the future?

Once this information is on the table, the feedback receiver and
giver have substantial issues to discuss, and their conversation can
be a productive problem-solving session that gets at important
issues and works toward their resolution.

Action Idea 4: Avoid Communication Games

So far, this chapter has presented information about performance
discussions as though all it takes to make them successful is the
right combination of motivation and skill. In reality, however, man-
agers and employees sometimes play communication games,
which create barriers to effective feedback discussions and divert
attention from important feedback issues. When these games are
played, messages go underground, thwarting the important goal of
being On-The-Level in the feedback interchange.

Everyone plays games at some time — whether as a receiver or
sender of feedback. It's important, however, to know what they are,
recognize them when they are played, and stop them before they
seriously interfere with what you're trying to accomplish.

Games Feedback Senders Play

See if you recognize yourself or others in them. Then, the next time
they or games like them are played, stand back, assess the situation,
and bring the discussion back to a more direct exchange.

Five common games that managers and others who give feed-back often play are listed below.

It's My Duty: The game of obligation. In this game, the sender gives feedback totally out of obligation. He/she may fill out forms and satisfy other require-ments, but makes no commitment to sharing observations, solving prob-lems, or using the discussion as an aid in managing a productive unit. *The results?* For the receiver, this creates a cold, impersonal, and peripheral expe-rience. He/she is unlikely to ask questions or solve problems. The sender can hide behind forms and use this game to avoid getting personally involved or address-ing real issues.

Junk Dealer: The game of burying the message. Here the sender buries important messages with qualifiers, reservations, or irrelevant information such as "You don't have to agree with this," and "Ah, er, you might need to check this out because I'm not really qualified to . . . " By the time he/she gets to the point, the trash around it has covered the message. *The results?* This game makes it difficult for the receiver to hear and know what to do with the message. The sender avoids having to be direct and clear and avoids putting the message on the line.

Life Saver: The game of denying that the feedback is serious. Sometimes, after communicating negative feedback, the sender feels remorseful about drowning the receiver in bad news. He/she may then throw out a "life saver" such as "Well, don't worry about it. It's not that important anyway" or "You're really a great performer in these other areas." *The results?* This game reduces the impact and importance of the feedback and reduces the seriousness of any action planning that may follow.

Detective: The game of asking leading questions. In this game, the sender asks leading and unnerving questions instead of getting to the point. "Did you know that this would happen? Then, didn't you expect to have to . . . ? And wasn't it clear from my requests that you would need to . . . ?" *The results?* Though this may be an excellent technique for trapping criminals, it can damage trust and raise suspicions and defensiveness in a feedback situation.

Swami: The game of guessing the other person's thoughts. In *Swami,* the sender delivers indirect messages about the feedback, expecting that the receiver will be able to interpret non-verbal clues or will know what he/she is thinking. Here are some examples of the thinking that frequently accompanies this game: "He should know this is a problem without my telling him" or "She must be blind not to see she's off

track." *The results?* The receiver may get the message about the other's frustrations, but may not know what the real issues are. The sender may use his/her anger about the situation as an excuse to avoid taking responsibility for giving On-The-Level feedback.

Saying what you mean is the hardest job a feedback sender faces. *It's My Duty, Junk Dealer, Life Saver, Detective,* and *Swami* are all games that help the sender avoid making disclosures and being direct.

What can the sender do to avoid or reduce the impact of these and other games? The main solution is to take responsibility for saying what you mean. It is your job to lay the message on the table, to be On-The-Level. It's the receiver's job to hear the feedback and decide what to do with it.

Games Feedback Receivers Play

Feedback receivers use diversion tactics, too. Here are five common games receivers play.

Wounded Animal: The game of making the manager feel guilty. In this game, the receiver interprets the feedback to apply more broadly than the manager intends. He/she looks hurt, pouts, or even sulks for days. This can cause the sender to feel so guilty that he/she avoids giving constructive feedback in the future. The results? It can ruin open, direct, On-The-Level communication if the manager begins to take responsibility for how the employee receives the message. The biggest loser, of course, is the receiver. Few people will want to be direct with him/her if the only result is pressure to feel guilty.

Change the Scent: The game of diversion. Here, rather than checking for understanding or asking for more details, the receiver quickly changes the subject after he/she has gotten feedback. *The results? Changing the Scent* prevents the two parties from drawing conclusions and from exploring issues. Feedback sessions go nowhere.

Counterattack: The game of defend yourself at any cost. This game is the ultimate in defensiveness — the receiver initiates it even before hearing and exploring the feedback. It involves the receiver's countering feedback with a "Yeah but, you don't understand" or "If you were in my shoes . . . " or with a comeback or a reason why the sender is wrong or is even responsible for any problems. *The results?* This game stops

the listening process and can initiate a series of defensive statements on both sides that make direct dialogue impossible.

Ally Building: The game of safety in numbers. The objective of this game is to get as many people on your side as possible, so that you don't have to deal with feedback. The receiver's tactic is to collect allies to prove the feedback is wrong. *The results? Ally Building* helps the receiver avoid listening to and acting on feedback. Though it's appropriate to check out other opinions, being obsessed with building allies can prevent effective discussion and cause the receiver to miss an opportunity for growth and improvement.

Masochist: The game of being hard on yourself. In this game, the receiver punishes him/herself so that the manager won't have to. It often occurs when the receiver fears the worst and does not check to see what the manager really thinks. *Masochist* is commonly played by overachievers who chronically are harder on themselves than anyone else. "I'm a failure." "I can't do anything right." "I'll spend my vacation changing things." This game can also be used to manipulate the sender into giving positive feedback. For example, a manager may want to give constructive criticism to someone playing *Masochist* but may end up playing a *Lifesaver* instead. "It's not as bad as you think. Let's look on the bright side." In this case, a sender's game and a receiver's game work together to help both parties avoid the point of feedback communication. *The results? Masochist* requires so much negative self-talk and mental preparation on the part of the receiver that he/she may have no room for any new feedback. The sender's message is rarely heard if, in fact, it ever gets out in the first place.

Most receiver games are smoke screens designed to help the receiver avoid getting the message or taking action. The receiver's most difficult and important job is to hold back defenses and really listen. This is easier to do if the receiver focuses on the feedback's potential value — for growth and improvement — rather than on its threats.

Action Summary

Feedback sender and receiver games are common communication ploys. When they take over in review discussions, On-The-Level communication can be ruined and trust levels damaged in a way that can make subsequent discussions and reviews more difficult and defensive.

It is critical for both MANAGER and EMPLOYEE to take the following steps:

- Be on the lookout for communication games. Know them when you see them and be able to cut them off. This can happen if you both talk about recurring games and then work together to stop supporting each other in games that prevent direct exchanges and genuine listening.

- Resolve to replace games with improved feedback skills — observing, listening, empathizing, questioning, concluding, and describing.

Action Idea 5: Keep the Human Element

Feedback communication occurs between two human beings. This means that it is always a partially subjective process that can't be mechanized or substituted by a form or a computer. In order to work, feedback communication must involve *judgment, questioning, empathy, and personal commitment.*

Certainly it is important to be as objective as possible when trying to describe and assess performance. It's also essential to recognize and stop communication games. But these efforts will be only as effective as the level of trust that exists between manager and employee. Both must talk about their concerns, opinions, and reactions — they must include the human element in their discussions. And they need the skills of giving and receiving feedback communication.

Are you frustrated about the quality of your feedback discussions? Do you feel that communications between you and your boss or employees are not as direct and effective as they should and could be? Do you feel that games often get in the way? If you answered yes to any of these, you may want to improve the quality of your review sessions by talking about your concerns and your view of how you think feedback communication should be. This simple step can go a long way toward establishing a constructive atmosphere that keeps a human element in On-The-Level discussions.

Action Summary

This action idea has specific implications for managers and employees alike. As a MANAGER, you can take the following steps to keep the human element in your On-The-Level conversations:

- Clarify how you feel about discussing outputs, competencies, and style. What do you look forward to? What pitfalls do you want to avoid? What concerns you most about how you or your employees may approach a discussion?

- In a meeting or in individual discussions with employees, communicate that you want performance reviews to be On-The-Level. Describe what specific actions you will take to improve the quality of reviews and to help employees feel more comfortable with direct discussions. Then act on your commitments.

- Don't expect performance feedback discussions to be perfect or to proceed according to the book. Do expect the skills both you and your employees bring to review discussions to steadily improve. Conducting a performance review is a human and complex process. If you or your employees make a mistake, slip into a game, or talk when listening is required, forgive them and yourself and move on. Avoiding the issue won't help improve the quality of feedback discussions. Acknowledging and accepting the human component will.

EMPLOYEES also have a role in preserving the human element:

- Clarify how you feel about participating in performance review discussions. What do you look forward to? What pitfalls do you want to avoid? What concerns you most about how you or your manager may approach the discussion?

- Talk with your manager about your concerns, and express yourself in the first person. For example, "I've been frustrated in the past . . ." or "I like the way we've discussed . . ." or "I'm reluctant to talk to you because I

expect . . ." Work with your manager to establish ground rules for your next discussion.

- Don't expect performance review discussions to be perfect or your manager's skills to be flawless. Do expect, however, that both of you will steadily improve your communication skills as you develop a broader perspective and as you become more familiar with each other's communication style.

Action Idea 6: Focus on Outputs, Competencies, and Style

Discussing and evaluating performance is a complex task because the things that individuals do from day-to-day have both *short- and long-term implications.* This means you must discuss not only what the employee has accomplished, but also how the accomplishments were achieved and what impact they had on others in and outside the organization. It also means discussing the knowledge and skills the employee used, or should have used, in situations where his/her competencies were key factors.

The way to discuss accomplishments and their impact is to focus performance reviews on the three dimensions of performance: outputs, competencies, and style.

In a discussion about *outputs,* the goal is to review what the employee has achieved. This means answering questions like the following: To what extent has the employee met the responsibilities of the job as they are described in the job description? To what extent has he/she met specific goals? If goals and their excellence criteria were negotiated at the beginning of a year or project, the latter question can be answered simply by comparing actual achievements with goals.

The purpose of discussing *competencies* is to pinpoint the types and level of expertise required in the job and to compare the individual's current knowledge and skill level with those requirements. Answering the following questions will help you make these assessments:

What types and levels of thinking skills, business knowledge,

interpersonal skills, technical knowledge, and physical skills are required by the job?

What is the employee's actual expertise in each area?

Where do the major gaps between required and actual levels occur?

In what situations have the employee's competency strengths been valuable?

In what areas have weaknesses caused problems?

The answers to these questions can often help identify the causes of performance problems and the sources of performance strengths. They also set the stage for development and career planning discussions.

In the discussion of *style,* the goal is to review how the employee gets things done. Style must be discussed if it is affecting the individual's own work quality or ability to work with and through others. These are the questions to answer concerning style: What elements of the employee's style — how she/he works and works with information and people — have positive or negative effects on performance quality? What specific incidents support these conclusions?

Discussing style is no small responsibility. If style issues are affecting performance or the manager's decisions to delegate work or to provide career opportunities, then it is a matter of management ethics to let the employee know clearly where he/she stands. Style cannot be a taboo topic in performance reviews any longer. If it's affecting performance or an employee's current or future job options, it must be discussed.

Action Summary

Both the employee and the manager must be ready to discuss outputs, competencies, and style. Though these discussions may provoke short-term anxieties, they will yield long-term payoffs in the form of open, honest relationships, strengthened communication skills, and improved performance.

As a MANAGER with important responsibilities for assuring the quality of these discussions, you must do the following:

- Initiate formal review discussions when your organization requires them. In addition, encourage employees

to ask for performance reviews. Everyone can gain when employees take the initiative and are responsible for their own performance and improvement.

- Prepare to discuss the employee's performance by answering these questions: To what extent has the employee accomplished his/her goals and carried out the job's responsibilities? What skills and knowledge are strengths for the employee in the current job? What needs development? How does the employee's style aid and/or inhibit the ability to get work done with and through others? What specific examples from his/her performance can you cite to support your conclusions about outputs, competencies, and style? If you must complete forms, use them to help you think about these issues. Your notes and ratings will only be valuable if they help you have a quality discussion.

- Ask yourself if your biases have affected any of your conclusions. Watch for haloing, stereotyping, identifying, and projecting (as discussed in Chapter Two). Purge your feedback list of any items that relate more to your biases than to the employee's performance. Seek out third-party opinions if you feel your perspective isn't clear enough to support a conclusion.

- Effectively use communication skills. Listen, empathize, and ask questions so that you thoroughly understand how the employee sees his/her own performance. Be willing to change your conclusions if the employee's feedback warrants it. But also be ready to assert your conclusions and retain them if you feel your judgment is sound. Remember, you are paid to draw conclusions about performance.

- Watch for signs of communication games and stop the games immediately. Be On-The-Level, direct, and open.

- Think about the long-term payoffs when you are momentarily uncomfortable. For example, remember

that you are helping someone develop, managing with integrity, keeping the slate clean, or doing something to improve productivity.

- Support the employee's efforts to be direct. How you react to the employee's conclusions and disclosures will have dramatic effects on his/her willingness to be On-The-Level with you and other managers in the future. Never punish responsible, honest, open communication. The breach of trust that such action can cause can haunt you far into the future.

The EMPLOYEE'S list of responsibilities incorporates many of the points developed in previous sections of this book:

- Initiate a formal performance review when you want to discuss your manager's and your own overall view of your performance. Don't feel you have to wait for your manager to decide to have a review.

- Prepare for your performance review discussion. Draw conclusions about the quality of your own performance: To what extent have you accomplished your goals and carried out your job responsibilities? What skills and knowledge are strengths for you in your current job? What needs development? How does your style aid and/or inhibit your ability to get work done with and through others? What specific examples from your performance will you cite to support your conclusions about your outputs, competencies, and style? If your company provides or requires review forms, complete a set yourself before you talk with your manager. Use the forms and any other notes to help prepare you for a quality On-The-Level discussion.

- Effectively use communication skills when you discuss your performance. Listen, empathize, and ask questions so that you thoroughly understand your manager's feedback. Accept your manager's feedback about how he/she sees your performance. If you disagree with your manager's conclusions or have additional perspectives,

clearly state your conclusions and support them with specific examples from your performance.

- Watch for signs of communication games, and stop the games immediately.

Where Do You Stand?

How strong are your feedback practices — both giving and receiving feedback? Your answers to the following questions will help you think about that important issue.

. . . in YOUR JOB:

- When you need or want feedback on your outputs, competencies, or style, how often do you ask for it?

- When you get vague feedback — either positive or negative — how often do you ask for more specific information?

- When you get negative feedback, how often do your feelings and defensiveness get in the way of hearing and acting on information?

- How often do you leave discussions about your performance feeling that important issues have not been fully aired?

- How often do you think about the long-term results and benefits you want from On-The-Level performance discussions?

- When you discuss your own performance with your manager or others, what do you do to set an open climate? Do you use your receptive communication skills? What do you do to bring the best information to the discussion? Do you use your expressive skills? What skills are your strongest? Weakest?

- To what extent do you try to be "perfect" in your communications about performance? Can you accept your own tendency to be defensive? Your own humanness? What do you say to yourself when discussions don't go as well as you planned?

- How respectful are your discussions with others? Do you approach each other with concern and acceptance of your worth as individuals? Does your behavior toward others reflect how you want to be treated?

. . . as a MANAGER OF OTHERS:

- When you have drawn important conclusions about an employee's outputs, competencies, or style, how likely are you to communicate your observations?

- Do you hesitate to deliver feedback because you are concerned about how the employee will respond?

- When you have something important to say to an employee, how often does it feel like the entire burden for the success of the feedback discussion rests on your shoulders?

- How often do you leave discussions of an employee's performance feeling that important issues have not been fully aired?

- How often do you think about the long-term results and benefits you want from having On-The-Level performance discussions?

- When you discuss performance or other tough issues, are you usually more expressive? Do you question, conclude, describe more often than you observe, listen, empathize? How appropriate and effective has the balance been? What skills are your strongest? Weakest?

- To what extent do you try to be "perfect" in your communications about performance? Can you accept your own tendency to be defensive? Your own humanness? What do you say to yourself when discussions don't go as well as you planned?

- How respectful are your discussions with others? Do you approach each other with concern and acceptance of your worth as individuals? Does your behavior toward others reflect how you want to be treated?

Based on your answers, what do you want to improve about your feedback practices — how you give feedback — how you receive it?

The Main Point Is . . .

On-The-Level feedback is clearly a *shared responsibility.* In order to carry out their responsibilities and reap long-term payoffs of effective performance communication, both managers and employees need to take the following steps:

- Know what's in it for you.

- Strengthen your feedback discussion skills.

- Organize your thoughts for feedback.

- Recognize and avoid communication games.

- Implement performance review as a human process.

- Review and discuss feedback focused on outputs, competencies, and style.

This chapter has explored each of these areas and proposed actions the manager and employee can take to make the review process successful for themselves and for their organization. The performance review process works only when employees and man-

agers strive to make performance discussions informative, On-The-Level, and performance-focused exchanges. The effort expended by employee and manager is worthwhile in terms of the productivity, trust, and improved relationships that inevitably result from On-The-Level feedback discussions and performance reviews.

Action Notes

What points do you want to remember from this chapter?

What action ideas will you use?

DELIVERING AND DIGESTING TOUGH MESSAGES

Karen has worked for John for three years, and as her performance reviews show, she has been an effective auditor. She has been sitting on a tough message for her boss. She doesn't think that John is giving her a chance to do enough challenging work. She doesn't want to insult John, but Karen feels that, in general, he doesn't do enough to help his people grow and develop. Every night as she drives home, she thinks about how she can convey what she wants to say without getting excuses or, worse yet, an angry response from John.

John has worries of his own. He's concerned about Bill, a failing employee in his group. For the past several weeks, John has been wondering how he is going to tell Bill that if things don't change he'll lose his job. "It's easy to lay it on the line with people who just don't try," he thinks, "but how can I tell someone who's really trying that what he's doing just isn't good enough?"

Because Karen and John are not confronting their problems, they arrive home every night with their stomachs tied in knots.

Common Pitfalls When Delivering and Digesting Tough Messages

Both the manager and the employee are responsible for effective and early discussion and resolution of problems. Unfortunately, making this happen isn't as easy as it sounds. Here are the pitfalls:

Often employees detect that problems are occurring, but *rationalize their own role and responsibility.* Thoughts such as "It's my manager's job to fix this" help individuals avoid analyzing, discussing and eliminating problems.

Managers and employees often *avoid and ignore talking about problems* until the problems get so big or have gone on for so long that they are crises. When the discussion finally occurs, it is often too late for effective problem solving, and the discussion itself usually is charged with defensiveness, blaming, and helplessness.

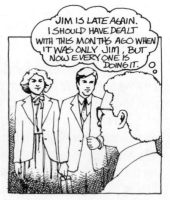

Frequently, managers *raise and discuss problems and then try to plan improvements in a single conversation.* This does not allow either the employee or the manager enough time to manage potentially defensive reactions. Problem solving under these conditions is difficult and usually not very effective.

Frequently, feedback givers turn to the *Swami* and *Junk Dealer games* described in Chapter Three. They make comments, give partial feedback, and briefly raise important issues as though they are incidental, hoping their message will sink in with just a few veiled comments.

Often managers *legislate improvements in performance without involving the employee* in the action planning or without assuring that the employee commits to real action. If the employee doesn't personally commit to changing his/her behavior and its results, even the best action plans are useless. If the employee lacks the skills and/or support to implement the action plan, it's a waste of time. It's one thing to be clear about the performance changes required, their timetable, and the

DELIVERING AND DIGESTING TOUGH MESSAGES

consequences of not changing — it's another to assume that mandated action and development plans will be carried out.

Feedback discussions always require the manager and employee to provide clear, specific information and conclusions, and to listen, ask questions, and show empathy. When feedback carries a tough message, however, additional steps must be taken to assure that complete communication takes place.

This chapter is about delivering and digesting feedback that communicates tough messages like these:

- Unless performance improves, an unsatisfactory performance rating, involuntary demotion, or termination will occur.

- Skill or style problems are seriously affecting the employee's performance or ability to work with others.

- Problems exist that are seriously affecting the employee's career opportunities in the organization or the manager's willingness to delegate work to the employee or involve him/her in important new work assignments.

- Executives have decided to reduce the number of people in the organization, and some employees must be told they will lose their jobs.

Many managers and employees say the hardest part of their job is delivering and digesting messages about performance problems or other issues that could lead to termination or other serious consequences if left unaddressed. Difficult as it is, when performance problems exist, tough messages must be delivered and digested — directly, clearly, and immediately. Sidestepping, avoiding, and game playing may delay the confrontation, but they inevitably make a problem situation worse.

What makes some messages tough to give and receive? Here are some reasons why MANAGERS feel uncomfortable and anxious about discussing performance problems:

- They don't like making judgments and evaluations that will have serious consequences for others.

- They are afraid of counterattacks and want to avoid being put on the defensive.

- They are afraid of losing or damaging the relationship they've established with the employee.

- They are afraid the employee will quit or will stop performing in areas where the manager is counting on continued performance.

- They don't feel comfortable or competent enough to evaluate people who may be their technical or professional peers or superiors.

EMPLOYEES on the receiving end of tough messages may be tempted to avoid confrontation and to play games for these reasons:

- They question whether they have the ability and/or energy to turn the situation around.

- They don't understand why things are going wrong and don't want to expose their fears and concerns.

- They have had negative, punishing experiences in past performance discussions and want to avoid similar situations.

- They are uncomfortable discussing their performance with a manager who is not their technical equal.

Action Ideas for Giving and Getting Feedback

These four action ideas can help managers and employees open and use direct communication channels during these difficult times:

1. Don't wait — discuss problems before they become crises.
2. Define your view of the problem or situation before discussing it.
3. Focus discussions on the problem.
4. Get employee commitment to action.

DELIVERING AND DIGESTING TOUGH MESSAGES

Action Idea 1: Don't Wait — Discuss Problems Before They Become Crises

One of the most common ways of dealing with performance problems — for manager and employee alike — is to avoid them and hope they go away. Yet, it's to everyone's benefit to face problems, discuss them, and try to resolve them in their early stages, before game playing and avoidance become recurring patterns. This also prevents the problem from growing to dimensions that require really serious and extreme solutions.

It is the manager's responsibility to recognize and address performance problems immediately. This responsibility does not depend on the manager's technical or professional stature. It does not require that the manager possess extraordinary judgment or evaluation skills — although all managers should continually refine their ability to draw conclusions about performance. Rather, addressing performance problems is a key part of the manager's role. A manager's failure to confront employee performance issues is itself a performance problem. Whether the manager is comfortable with it or not, confronting problems is part of the manager's job.

This does not mean that employees are not accountable for their performance. In fact, in an environment where employees "own" their goals, employees should recognize issues before their manager detects them. Why? Because they are closer to their own performance than their manager is. *Ideally, the employee should be the first to raise problems for discussion and feedback.* Also, employees are likely to be more receptive to, and to act on, feedback and problem solutions if they have initiated the discussion.

Regardless of who initiates the feedback discussion, though, problems must be addressed when they first appear. The first, and perhaps the most important, action idea for dealing with situations that require tough messages is don't wait. Talk about problems before they become crises.

Action Summary

Discussing problems immediately, before they become crises, requires work from both the manager and the employee. As a

MANAGER, your role in responding to problems immediately includes taking the following steps:

- Don't wait. Set a time to discuss and resolve the issues as soon as you become aware of behavior or results that may jeopardize (1) an individual's performance rating; (2) your willingness to delegate to the employee and involve him/her in more challenging work; (3) how you talk about the employee with third parties; and (4) the employee's career options.

- If you avoid discussing certain issues, ask yourself what's getting in the way. Are you concerned about making judgments? Are you worried about counterattacks from the employee? Are you afraid of losing the relationship or other valuable contributions the employee makes? Is the employee your technical equal (or superior) whom you don't feel comfortable confronting? Be honest with yourself about your concerns. Then remind yourself that it will be easier to solve the problem now than later and that it is your job as a manager to be sure that tough messages are delivered and heard at the earliest possible time.

- Encourage the people who work with you to recognize problems. If your employees can't manage a problem themselves, let them know it's appropriate to discuss situations with you — before they become serious issues. Then, be sure you don't punish their initiative.

As an EMPLOYEE, your role in effectively handling situations that require tough messages is to do the following:

- Keep a watchful eye on your own performance — your outputs, competencies, and style. When you detect problems, decide to do something about them immediately. Don't wait.

- Initiate discussions about performance problems. If you raise the problem first, your manager will likely be less anxious about being direct. You'll probably get

more support and you won't need to be as defensive as if the boss raised the issue.

- If you notice that you're not discussing the problem with your manager, ask yourself what's getting in the way. Are you concerned about whether you have the ability and energy to turn the situation around? Are you suspicious of your manager's intent or concerned about his/her ability to deal with you fairly? Do you believe your manager is not your technical superior and therefore shouldn't have authority to assess or classify your performance? Whatever your resistance, don't let it get in the way of raising and resolving problems when you see them affecting your performance rating, your manager's trust, your credibility and relationships with others, or your career opportunities.

Action Idea 2: Define Your View of the Problem Before Discussing It

Once a manager has decided to face a problem, he/she may be tempted to pick up the phone immediately or walk over to the employee's office to "set things straight." This can lead to a volatile and defensive situation.

How performance problems are managed can have lasting impact on the relationship between a manager and employee and on the likelihood that the problem will be resolved. The stakes are usually high enough to warrant planning — for both parties.

For the manager, this means being clear about concerns and having examples of the employee's actions in specific situations. Managers must also spend some time thinking about their own biases and how they may be affecting their interpretations and conclusions about the employee's performance and the magnitude of the problem.

Employees, too, must prepare for discussions about performance problems. They must spend some time thinking about the problem and its potential causes. They may need to spend some

time alone to reduce any defensive reactions that could interfere with the quality and success of the discussion.

Both manager and employee are responsible for laying information about the problem on the table, and they both need time to prepare. This means that whenever possible, the person initiating the discussion should briefly introduce what he/she wants to talk about and then set up a separate meeting time for a detailed discussion. Here are examples of introducing the problem and setting another time for discussion: "I want to talk to you later today about the problems you seem to be having with the data processing group," or "I think I've blown several key sales calls and want to talk with you in the next few days about improving the situation."

When both parties are given time to think and prepare, "knee-jerk" defensiveness can be reduced. Defensiveness often occurs in discussions where tough messages are delivered, digested, and discussed in a single conversation.

Action Summary

As a MANAGER, defining your view of the problem requires that you do the following:

- Take some time to think about these questions: What are you concerned about? What specific situations have you observed that give you evidence that a problem exists? (In addition to your own observations, feedback from third parties and other indicators can also provide evidence of a problem.) To what extent is your opinion affected by your own biases? Watch for haloing (where your overall impression affects your objectivity), stereotyping (where attitudes toward a class of people distort your perceptions), identifying with (where the employee's similarities to you are a key factor), and projecting (where you assume motives).

- Get feedback from a third party if you have strong biases that affect your objectivity about the employee. This process lets you test the validity of your observations before you talk with the employee.

DELIVERING AND DIGESTING TOUGH MESSAGES

- Ask yourself what the consequences will be if the problem continues. Will it lead to an unsatisfactory performance rating? Will it affect your willingness to delegate, to involve the employee in key tasks, and to recommend him/her for career opportunities? Could the problem result in termination or other negative consequences? If the answer is yes to any of these questions, then tell the employee you want to discuss the issue, and set a time within the next few days to do so.

- Fully discuss the problem, and if there has not been acceptable progress to eliminate it, write an official letter notifying the employee of the need to improve. For the record, spell out the consequences of not resolving the issue in a specified time period. This notice should be included in the employee's personnel file.

- Ask yourself how comfortable you feel about being direct with the employee. Are you reluctant to make judgments? Are you afraid of counterattacks or concerned about damaging your relationship with the employee? Are you concerned that the employee may quit or stop performing in other areas? Are you reluctant to evaluate someone who is technically senior to you or is a professional peer? These concerns cannot be excuses for avoiding confronting a problem. Being honest with yourself about your own barriers can help you manage yourself in a situation where you have a tough message to deliver.

As an EMPLOYEE, defining your view of the problem requires the following:

- Initiate a discussion when you realize you have a performance problem that may jeopardize your current or future job status. Tell your manager you want to take time in the immediate future to discuss the issue. Set a date and a time.

- Before you discuss details of a problem with your manager, take some time to review the problem alone. Try to

be as nondefensive as you can, and set excuses and rationales aside. Define your view by carefully answering the following questions: What are you and/or your manager concerned about? In what specific situation has the problem occurred? What happened? What do you think is the cause of the problem(s)? Unclear goals? Lack of skill? Stress, fear, or lack of confidence? Your style of working with people or data? Lack of support? What evidence supports your conclusions?

- Ask yourself what might interfere with your ability to have an On-The-Level discussion with your manager. Anxieties? Negative feelings about past discussions with him/her? Concerns about getting negative feedback from someone you feel is at the same or even a less accomplished professional or technical level than you? Disagreements about the problems or issues? If the interference is strong, talk with your manager about it before you attempt to discuss the performance issue itself.

Action Idea 3: Focus Discussion on the Problem

Even when performance problems appear to be related to style, it is unrealistic to make broad, unsubstantiated negative statements about an individual and hope that improvement will occur. Avoid making statements like these: "You're an autocrat," "You're a weak performer," or "You're impossible to get along with." Such statements raise an employee's defenses and fail to provide a basis for problem solving.

The feedback you give and statements you make about the performance problem must be firm and strong. This is especially true when the problem is very serious and when major changes must be made in a short time. However, when feedback contains a tough message, it is especially important that it be focused on the problem and be as specific and well substantiated as possible.

It is the responsibility of the discussion initiator to establish the

initial focus of the discussion. Throughout the conversation, however, both manager and employee must work together to assure the results will be constructive.

Action Summary

As a MANAGER, your responsibilities in focusing the discussion on the problem include the following:

- If you have initiated the discussion, then spend the first few minutes of the meeting describing your concerns, talking about the consequences you feel may occur if the problem persists or worsens, and laying out your evidence that a problem exists.

- Avoid communication games such as *It's My Duty, Junk Dealer, Life Saver, Detective,* and *Swami.*

- Admit any major fears you may have about raising the problem for discussion. It's OK to be human, and demonstrating your humanness may set the stage for a less defensive exchange.

- Listen to the employee's concerns, conclusions, and evidence. Ask questions. Be sure you understand his/her views before you draw final conclusions.

- By the end of the discussion, be sure you and the employee have the same understanding of how you view the problem and its potential consequences. Because you are the manager, your definition of these issues must take precedence. The employee, however, always has the right to appeal. But if your discussion has been frank and clear, if both you and the employee have listened and clarified each other's views, your conclusions should be mutually acceptable and understandable.

As an EMPLOYEE, your role in focusing a discussion on the performance problem includes the following:

- If you have initiated the discussion, spend the first few minutes of the meeting describing your concerns, mak-

ing a statement about the consequences you feel may occur if the problem continues, and laying out specific evidence that a problem exists. Be sure you admit any fears you may have about raising the problem for discussion. And don't slip into communication games.

- Listen and ask questions to be sure you thoroughly understand your manager's concerns, conclusions, and evidence. Avoid playing games such as *Wounded Animal, Change the Scent, Counterattack, Ally Building,* or *Masochist.* Keep communication direct and On-The-Level.

- Clearly describe your own concerns, conclusions, and evidence. Present these as information that you're putting on the table — not as counterattacks or diversions.

- Realize that it is the manager's job to draw final conclusions about performance, to make judgments about the seriousness of problems, and to determine consequences. It is your job to draw and communicate your own conclusions, to try to appreciate the bigger picture that the manager's concerns may represent, and to decide whether or not you will commit to the changes your manager (and possibly you) believe are required. Of course, it is always your right to appeal disagreements to management at higher levels.

When a tough message needs to be delivered, it is the manager's responsibility to be sure all the facts are on the table, to draw and communicate conclusions, and to be clear about the consequences of maintaining the status quo. It is also his/her job to follow up with a formal, written notice of the need to improve if the situation does not turn around in a stipulated period of time. Unless an employee appeals an issue to higher authority, the manager must decide whether major change is necessary. In the best discussions, of course, these decisions are made jointly, and commitment to change is strong on both sides. *Mutual commitment* is more likely to occur if the discussion itself has focused on specifics and problems, not on generalities and personalities.

DELIVERING AND DIGESTING TOUGH MESSAGES

Action Idea 4: Get Employee Commitment to Action

Though it's the manager's responsibility to be clear about his/her view of the problem and the consequences of not resolving it, it's the employee's job to plan and implement actions for improvement and development. The point is, the employee's commitment to action and ability to act are key to solving the problem. If the employee doesn't personally commit to changing his/her behavior and its results, or if the employee can't carry out action plans because he/she lacks the skills or resources, then improvement plans will be useless.

The employee's commitment can come from fear of consequence, from wanting to do the job better, from having participated in solving the problem and making an agreement to improve, or from just being clearer about the issues to address and situations to change. Whatever its source, the commitments and actions must be the employee's.

At the end of a discussion of performance problems, a manager and employee should check out the employee's current awareness of the problem, its consequences, and his/her intentions to act. One possible outcome of an effective discussion of performance problems is that the employee will claim ownership of the problem and commit to working to solve it (if, in fact, it is the employee's problem). Another possible outcome is that the employee will decide not to improve or change — a decision that is his/her right to make. When this happens, the manager, representing the organization, can take the actions that result from the employee's decision.

Action Summary

There are several ways MANAGERS can help develop employee commitment to action:

- Don't do all the talking in a discussion that requires delivering and digesting tough messages. Listen to the employee's views of the situation and to his/her views of what needs to be done to improve it.

- As a last step in the discussion, ask the employee to summarize what he/she sees as the problem and its

consequences. Ask what action and results he/she is willing and able to commit to. Then set a mutually acceptable timetable for action and a checkpoint for evaluation.

- Recognize that the employee has a right to decide not to change or to appeal the situation to higher authority. It is better to address these issues directly than to pretend there is commitment and agreement when there is none.

There are several important ways the EMPLOYEE can develop a commitment to action:

- Before you leave a discussion of a performance problem, be sure you understand the manager's view of the problem and the consequences that will occur if it is not resolved.

- If you are not willing or don't feel able to take the steps required to change the situation, say so. Explain your reasons and, if you can't negotiate and commit to an agreement, be prepared to appeal to higher authority or accept the consequences.

- If you accept the idea that changes are necessary, take responsibility for making them. Ask your manager for help and recommendations where appropriate, but set and adhere to timetables for action and improvement.

Where Do You Stand?

Think about these questions before you read further. Your answers will help you determine how strong your skills are in delivering and digesting tough messages.

. . . *in YOUR JOB:*

- When your manager tries to give negative feedback about your accomplishments, competencies, or style, how likely are you to respond with a communication game?

DELIVERING AND DIGESTING TOUGH MESSAGES

- If something is wrong in your work or relations with others on the job, how likely is it that you and your boss will discuss the problem before it becomes a crisis?

- How would you describe your work climate for raising and discussing problems with your manager?

- When you have had problems meeting your own goals, who has initiated discussions between you and your manager?

- How much time do you typically take to understand problem situations before you talk with your manager about them?

- What words best describe your discussion of problems and difficult issues: defensive or problem solving, well prepared or ill prepared?

. . . *as a MANAGER OF OTHERS:*

- When you notice a performance problem or see one beginning, how likely is it that you will bring the problem as you see it to the employee's attention?

- How often do you let small problems go unaddressed only to find yourself dumping a load of negative feedback or presenting the employee with an ultimatum to move or change?

- How would you describe your work climate for discussing performance problems? How likely is it that employees will bring problems to you before they are crises?

- How much time do you typically take to understand problem situations before you talk to your employees about them?

- What words best describe your discussion of problems and difficult issues: defensive or problem solving, well prepared or ill prepared?

- Do your discussions of tough situations and problems include time to plan specific action?

- How do you know actions will occur? How do you know you or the other person has a commitment to resolve the situation or to act?

Based on your answers and on your experience in situations requiring you to give or receive tough messages, what would you like to improve about your communication behavior and comfort level in these situations?

The Main Point Is . . .

Situations that require delivering and digesting tough messages challenge the best communication skills of the managers and employees involved. All the rules of giving and receiving feedback apply. (See Chapter Three.) In addition, there's a need to overcome the anxieties that frequently haunt both parties when issues are serious and may potentially affect a unit's success or an employee's work status.

Resolving tough issues is *not a paper-and-pencil process.* It requires face-to-face, On-The-Level discussions, sensitivity, and tough-mindedness from both parties. Unfortunately, many managers and employees avoid and misunderstand problem situations. Relationships and productivity suffer needlessly when this occurs.

By using the following action ideas, you can communicate On-The-Level when you're in situations that call for delivering or digesting tough messages:

1. Don't wait — discuss problems before they become crises.
2. Define your view of the problem before discussing it.
3. Focus discussion on the problem or situation.
4. Get employee commitment to action.

DELIVERING AND DIGESTING TOUGH MESSAGES

Action Notes

What points do you want to remember from this chapter?

What action ideas will you use?

DEVELOPMENT PLANNING

ACTION **1.** Identify Needs First PAGE 109

IDEAS **2.** Visualize the End Results PAGE 112

3. Develop an Action Strategy PAGE 113

Laura, the manager of a large customer service group, gives high priority to communicating what she wants and talking with her staff about how they're doing. "I like working for her," says Jim. "You always know where you stand." It's become clear, however, that many development issues she has discussed with her people don't get resolved over time. "I tell them how they should solve their problems, yet I don't always see any change. What more can I do?" Laura asks.

Laura needs a new way to think about helping her employees carry out improvement and development actions. Telling them what to do is simply not enough.

Common Pitfalls When Planning Development

Many managers and employees don't take individual development seriously. They spend very little time planning for it or managing its quality. Why does this happen?

Sometimes individuals are afraid to admit they need or want to develop and learn. They feel that *"development is only for the incompetent."* When managers convey this perspective to employees, development actions are superficial and rarely deal with important needs and issues. When individuals bring this perspective to their own lives, they may avoid many opportunities to grow and change.

Frequently, development plans and actions *aren't hard-hitting and don't relate to real needs.* Managers and employees may do a good job of observing performance and discussing outputs, competencies, and style. But unless the development planning that ensues is a good problem-solving process, the plans are likely to be shallow and off-target from both the individual's and the organization's perspective.

Formal development programs are sometimes used as *a special benefit or even as a place to send "topped out" employees.* When this happens, the real job and career purposes of development actions get distorted, and development becomes a synonym for soft management.

Development's short-term inconvenience may obscure the long-term payoffs. In order to become good at a skill or knowledgeable about a subject, an individual may have to study, practice, make mistakes, take time away from work, and risk criticism or even ridicule. Many people give up on development projects because the payoffs lose their allure or get lost in the day-to-day shuffle.

Often *development becomes an activity trap.* Managers or employees may equate development with hours spent reading books, attending courses or workshops, or preparing assignments. But development is not an activity, it is an output — a result. Unless they result in changed outputs, skills, or style, development activities are meaningless.

DEVELOPMENT PLANNING

Often development plans are *designed as though everyone had the same learning style.* Some of us learn faster and better on the job, others through reading, attending courses and workshops, or watching others perform. In short, the best development plan for you may not be the best for me.

Many people *plan in the dark.* They set development goals without taking time to find the best learning resources to use. This often means a longer, less focused development process than they would have faced if they'd done a bit of investigating first.

Development is the process of improving an individual's ability to perform. No one can afford to ignore it. Competencies, style, and values must keep up with, or ahead of, the job and personal changes that are inevitable in today's dynamic work environments.

Development is both a survival skill and a vehicle for personal fulfillment. Because it is so important personally and organizationally, development should be planned so that these results are achieved:

- Individuals have the ability to act on tough messages.

- Individuals resolve the output, competency, or style problems that may be limiting their current and future job options.

- Individuals are able to deal with new equipment, technology, systems, structures, and other changes affecting job requirements.

- Individuals can competently manage life changes that may be affecting job satisfaction or productivity.

In this chapter, you will learn how to manage the development planning process. It will help you increase your respect for and commitment to planned development as a critical aid to personal satisfaction and productivity.

Development action planning requires both a personal and an organizational perspective. When it's done well, the payoffs in terms of improved performance, broadened skill and knowledge, increased ability to manage change, and personal satisfaction can be very high. This phase of the performance management process deserves to be taken and managed seriously.

Action Ideas for Development Planning

Three action ideas can help assure quality development planning:

1. Identify needs first.
2. Visualize the end result.
3. Develop an action strategy.

If both the manager and the employee collaborate on the development plan, chances increase that it will be carried out.

Action Idea 1: Identify Needs First

If you've done a good job of observing and discussing performance, then you will have a solid basis for planning development. However, you may need to consider more than current performance when you devise a development plan.

Development needs fall into four major categories. A thorough development plan will take all of them into account:

1. Performance improvement needs. These are the needs to improve the quality of job outputs and to resolve skill, knowledge, and style deficiencies.

2. Career development needs. These are the needs to develop the skills, knowledge, and style that are important to the jobs an employee wants to pursue or that may be required if the current job is expanded.

3. Personal needs. These include personal skills that can help an individual cope with or manage personal issues that are affecting job performance or personal well-being.

4. Needs arising from changing job requirements and conditions. These may include needs to develop skills for using new technologies, generating new outputs, working on new products or services, implementing new policies and procedures, and working in a different organization structure or with new groups of people.

Identifying priorities among this diverse array of needs does not have to be a tedious, overly analytical process. Answering the six questions below can help set development direction:

1. What *performance areas* most need improvement? (See Chapter One.)

2. What *career directions* will the employee want and be able to pursue in the next few years? Moving up a level or into management? Moving to a new function or department? Moving to a position requiring greater technical expertise? Staying in the current job and focusing on doing it better? Staying in the current job as it is being performed? Staying in the current job but expanding it?

3. What *personal issues* that affect the job are placing new demands on the employee's time and priorities?

4. What *changes that will affect skill or style requirements* will occur in the job or organization during the next year or two?

5. Based on the answers to the first four questions, what *style* characteristics are most important for the employee to work on?

6. Based on the answers to the first four questions, what *skills and knowledge* will the employee need to develop? Consider skills and knowledge in the following five groups:

Thinking skills — taking the larger perspective and issues into account, recognizing priorities, and being able to analyze information and events.

Business knowledge — knowing the organization's strategy, goals, policy, and structure, and understanding the industry and organization's environment.

Interpersonal skills — working with people, developing and maintaining work relationships, communicating, and managing conflict.

Technical knowledge — understanding the tools and concepts of the function or technical area.

Physical skills — strength, dexterity, manual, and other skills.

Development plans must have direction. Since individual needs determine direction, the answers to questions like these are an important part of the development planning process.

Action Summary

As a MANAGER, you can help the employee set development priorities in the following ways:

- Point out the performance areas (outputs, competencies, and style) that really need improvement or that you think will be high payoff areas.

- Identify the job requirement and organization changes on the horizon that you believe will affect skill and knowledge requirements.

- Realize that development is fundamentally a personal matter and that all development is self-development. This means that whatever the development priority, the employee must accept it as a need that he/she is willing to address.

DEVELOPMENT PLANNING

As an EMPLOYEE, you must take charge of your development process in the following ways:

- Specify your development priorities. What aspects of your current job performance — outputs, competencies, and style — do you need to improve? What kinds of development relate to your career goals? Are your goals to stay in the current job, expand it, move laterally, or move up? What personal pressures can you address by strengthening skills, knowledge, or style? What development needs relate to pending changes in your job requirements or conditions? List your needs and identify the important areas for improvement before you plan any development goals.

- If your performance in your current job is not satisfactory, focus on your needs in this area only. Set career concerns aside unless you must make a job change because your current job is not a good fit. Competent performance in the current job builds the trust, reputation, and references on which later job changes may depend.

- Work with your manager or someone else you trust to prioritize your development needs. Get direction concerning the most important areas for action.

Action Idea 2: Visualize the End Result

It often takes a while to reap the fruits of development. Therefore, it is vital to develop a clear, positive vision of the benefits, payoffs, and reasons for embarking on a development project. The employee should ask: What will the new skill, knowledge, or style characteristic enable me to do? Where and when will I use what I've learned? Where will I be more effective than I am now? How will it feel? What will I gain?

Visions of the results, the events, people involved, actions, feelings, and accomplishments can be a powerful motivator when an employee feels stuck or when it seems that development actions are not worth the effort.

Action Summary

Here's a way MANAGERS can help employees visualize the results of development:

- Talk with the employee about what successful development will mean both for the current job and in the future. Discuss the opportunities that may arise if key skills or style characteristics are strengthened.

As an EMPLOYEE planning development, your ability to visualize can help you achieve your development goals:

- Develop a clear mental picture of what life and work will be like for you if you successfully develop in areas you have selected. Think about situations where you will be more effective. Who will be involved? Where will you be? What will you do and accomplish? How will you feel? How will others react?

Close your eyes and imagine specific situations. Etch a picture of success into your memory — feel what it's like. Then, recall this vision whenever you feel frustrated about your progress or defeated by the time and energy your development actions will take.

Action Idea 3: Develop an Action Strategy

Once the employee knows what he/she needs to develop, the next step is to select the best learning activities and resources to use. To make this decision, the employee must know what's available to assist learning and what resources will best fit his/her learning style. Then, he/she can design an action plan that will be efficient and appropriate.

DEVELOPMENT PLANNING

Action Summary

As a MANAGER, your role in helping employees prepare development plans includes the following:

- Recommend potential learning resources available within and outside of the organization.

- Negotiate checkpoints where you can provide support and feedback.

As an EMPLOYEE, you must do the following to develop an action strategy:

- Take time to find out if these or other options are available to help you address your needs:

 1. Coaching and one-on-one instruction
 2. Books
 3. On-the-job learning
 4. Courses and workshops
 5. Articles and journals
 6. Exercises, role plays, case studies
 7. Discussions and group meetings
 8. Self-instructional materials including workbooks and computer-aided learning
 9. Reflection, self-analysis, relaxation, meditation
 10. Working with mentors and people who are experts in your development areas
 11. Taking on a challenging project that really stretches your capabilities
 12. Watching experts, teaming up with experts

- Know what your best mix of learning activities is. How much theory do you typically need, how much practical experience? How much reflection, how much experimentation? What are the pros and cons for you of learning alone rather than with others or of learning in a formal program rather than on your own timetable? Do you remember key ideas best when you see them, hear them, write them down, or use them? Think about important knowledge or skills you've learned recently.

When you've both enjoyed and been productive in your learning, what have you done? What resources did you use? Try to design learning projects that fully accommodate and use your learning style.

- Develop an action plan and timetable for completing each project.

Where Do You Stand?

How strong are your development action planning practices? These questions can help you think about this important area:

. . . in YOUR JOB:

- What percentage of the development goals you set do you actually achieve? Work on? Forget about before you take any action?

- How good are your development action plans? Do you review a variety of options before you decide upon the best course of action, or do you act on the first development idea that occurs?

- Right now, what are your development goals? Have you stated them as actions (for example, to take a course) or as results (for example, to increase my financial skill to a level where I can prepare a development budget with no technical assistance)?

. . . as a MANAGER OF OTHERS:

- What support do you provide after your employees set development goals? How likely is it that you will actively support the individual's development? Track it? Forget about it?

- To what extent do you encourage your staff to review several development options before deciding upon what action they will take? Do you help brainstorm options?

DEVELOPMENT PLANNING

- Think of one of your employees. What are his/her development goals? How will achieving them affect his/her performance?

- As a partner for others' development, how do you typically help others set goals?

Based on your answers, what do you want to improve about your development action planning practices — how you plan for yourself or support others?

The Main Point Is . . .

Development planning is the final step in the performance management cycle. It depends on successful execution of the other steps. If goals are clear, if observations have been precise, if feedback has been given and received with skill, and if any tough messages have been thoroughly discussed, then development will have a strong focus.

Development planning can be effective and On-The-Level only if both the employee and manager get involved in the process. If both use the following action ideas, development planning becomes a way to address real needs and to assure that employee growth occurs.

1. Identify needs first.
2. Visualize end results.
3. Develop an action strategy.

Action Notes

What points do you want to remember from this chapter?

What action ideas will you use?

DEVELOPMENT PLANNING

ON-THE-LEVEL

CONCLUSION

Al hangs up the phone for the last time in a tough week. He's ready to go home, work out, and then relax during a four-day vacation. It's been one of his most satisfying weeks as a manager — in spite of several difficult moments.

First, Myrna, one of his experienced employees, told him she might want to extend a deadline. The sales department hadn't provided the information she needed to make a key advertising decision. Fortunately, his past encouragements to employees to "stop problems early" paid off in this case. Myrna had taken the problem as far as she could and had involved him when she ran into a stalemate. Al's involvement had been brief and appropriate. Through some tough negotiations with the director of sales, he had worked with the sales group to provide the support needed. The task was back in Myrna's hands, and the deadline was saved.

Then there was the situation with John. Al had passed him over for assignment to several important projects. John confronted him on Tuesday with this fact. "Why have you kept me in the background, Al?"

Al had felt good about his response, even though his anxieties about discussing style issues had been intense. "John, I guess it's because I'm not comfortable with your abrasiveness in sensitive situations. "I think your style has been a key factor in our loss of two small but potentially important accounts. I haven't seen you spend enough time listening to our customers — understanding what's on their minds."

The ensuing conversation had unearthed a number of issues, ones that had clearly influenced Al's decisions not to delegate certain tasks to John. During the discussion, Al had confronted John's *Wounded Animal* game and even stopped his own *Detective* tactics. Clearly, it would have been better if Al himself had initiated the feedback discussion about John's style as soon as he felt it affecting his decisions. But all things considered, Al felt good about what happened. John had felt safe raising the issue. Al and John had both short-circuited the games that usually interfered with their problem

solving. And Al had been able to express himself and give specific examples during a discussion of the formerly taboo area of John's style.

"I've come a long way from my early days as a manager," Al thought as he drove home. "I used to avoid performance discussions and merely told people at the end of the year what their performance ratings were. My staff has also taken on much more responsibility for the quality of their own performance and for our communication about it. They demand to know where they stand with me and with others in the company. We've unleashed a lion here by working on everyone's communication skills and attitudes. But it's sure easier to go on vacation now that I know I'm leaving behind responsible people — people who can and will deal with issues On-The-Level."

There is no guaranteed formula for performance communication. Nothing assures that the use of high levels of communication skill in any given situation will inevitably result in productivity and satisfaction at work. Often, direct communication about performance may be premature or may be so poorly timed that relationships between manager and employee are damaged almost beyond repair.

Realistically, most organizations and individuals do not suffer from being too skilled at communication. In most organizations managers and employees don't communicate at the levels necessary for communication excellence. They hold different views of what individual performance should be, where it fits in the big picture, how individuals are doing, and where they may be going in their organization. This murky view of performance does not have to be the standard, however. As a manager or employee, you can make your own performance communications clearer.

But is improvement really possible? Asking for and giving feedback that is not only sensitive to another person's needs but also is clear and direct can be difficult. Furthermore, feedback discussions are situational. The best approach depends on what we — and those who work with us — think and feel at different times. At this point, it is legitimate to ask "Is it possible to improve performance communication?" The answer to this question is a resounding yes! But the goal must be improvement, not perfection. Remember, this is a human issue, not a mechanical one.

How can you improve communication about performance? These five steps are key:

1. Imagine yourself in feedback discussions where things are going well. See yourself listening, helping, being honest, and being heard. This mental practice can help build confidence and can help you rehearse some of the skills you want to improve.

2. Prepare for feedback discussions whether you are giving or receiving feedback. Ask yourself "What do I want from this communication? Do I want a specific message to be heard? Do I know how I am being seen?" Remember that directness is irrelevant without direction. It is unlikely you will get what you want if you don't know what your priorities are. Preparation is the key.

3. Intend to be helpful. As you deliver your messages, think about how they are being received. Observe the effects your messages are having on the other person. Think about how you can help the other person hear what you are saying, and decide what to do about it.

4. Be responsible in what you decide to talk about. Review your judgments and opinions for biases, but then be sure you communicate all the important observations and conclusions you've drawn about your own or the other person's performance.

5. Seize every opportunity you can to use good communication skills — observing, empathizing, listening, questioning, describing, and concluding. These skills are important in family, church, and recreational relationships as well as at work. Improving them in one area will affect what you do in the others.

Imagine success. Prepare. Be helpful. Be responsible. Use every opportunity to strengthen skills. These are success ingredients for both managers and employees. The action ideas in this book on setting goals, observing performance, giving and getting feedback,

delivering and digesting tough messages, and designing development plans can help you in more specific ways.

The important point is this: On-The-Level communication skills *can always be improved.* And considering the benefits of clear communication for managers, employees, and the organization, any improvements you make will be well worth the effort!

ABOUT THE AUTHORS

PATRICIA McLAGAN

Patricia McLagan is Chief Executive Officer of McLagan International, Inc., a firm that provides programs and support for performance management, career management, and personnel development. The company assists organizations worldwide in managing and developing their employees. An internationally known speaker and consultant, Pat has brought innovative methods for improving communication and productivity to a broad range of industrial and service organizations and to emerging high-technology industries and government agencies.

Pat holds a master's degree in adult education with a special emphasis in industrial psychology and industrial relations. She is the author of many books and articles, including *Helping Others Learn: Designing Programs for Adults, Getting Results Through Learning: Action Ideas for Participants in Workshops and Conferences,* "Competency Models" *(Training and Development Journal),* Learning to Learn (a computer-based Plato program) and Models for Excellence: The Results of ASTD's Training and Development Competency Study. She is a past director of the American Society for Training and Development and the winner of that society's highest award for service and professional performance.

PETER KREMBS

Peter Krembs is an independent management development specialist who has studied and taught communications at Purdue University and the University of Minnesota. He is a recognized leader and facilitator who possesses a rare talent for engaging individuals and groups in developing and enhancing their ability to communicate about performance. He has helped many major organizations build management development strategies and is on the faculty of

management development programs within several of those organizations. In addition to his work on performance feedback communication, Peter designs and teaches workshops on coaching and counseling communication skills for managers.

Peter is the author of "The Technical Manager," a video-based training program published by Addison Wesley. He is also the author of several articles about helping technical specialists make the transition to management.

McLAGAN INTERNATIONAL, INC.

McLagan International, Inc. provides a wide array of consulting services and programs to help organizations manage and develop their employees. McLagan's On-The-Level System includes books, workshops, and facilitator training to help managers and employees improve communication, set goals, discuss performance, plan development, and manage careers. Services and products in the On-The-Level System reflect the principles and philosophy described in this book. For additional information write or call:

McLagan International, Inc.
1700 West Highway 36
St. Paul, Minnesota 55113
612/631-2034